What They Left Behind

Richard S. Buswell

What They Left Behind

PHOTOGRAPHS

RICHARD S. BUSWELL

FOREWORD by George Miles

INTRODUCTION by Victoria Rowe Berry

UNIVERSITY OF NEW MEXICO PRESS | ALBUQUERQUE

22 21 20 19 18 17 1 2 3 4 5 6

Library of Congress Cataloging-in-Publication Data

Names: Buswell, Richard S., 1945– photographer.
Title: What they left behind: photographs / Richard S. Buswell; foreword by George Miles ;
introduction by Victoria Rowe Berry.
Description: Albuquerque : University of New Mexico Press, [2017]
Identifiers: LCCN 2016010578 | ISBN 9780826357700 (cloth : alk. paper)
Subjects: LCSH: Photography, Artistic. | Commercial paraphernalia—Pictorial works. |
Industrial archaeology. | Landscape photography—Montana.
Classification: LCC TR655 .B885 2017 | DDC 770—dc23
LC record available at https://lccn.loc.gov/2016010578

FRONT JACKET PHOTOGRAPH: Richard S. Buswell, *Doll Arm*, 2015
BACK JACKET PHOTOGRAPHS: (*top left*) *Mind Bits*, 2013;
(*top right*) *Tire No. 2*, 2013; (*middle left*) *Abstract No. 1*, 2015;
(*middle right*) *Doll Parts*, 2014; (*lower left*) *Rattlesnake*, 2013;
(*lower right*) *Spine and Ribs*, 2014; all photographs by Richard S. Buswell
BOOK DESIGN: Catherine Leonardo
Composed in Adobe Garamond Pro 11/15
Display type is Univers Lt Std

IT MAY BE TEMPTING to regard the photographs in Richard Buswell's *What They Left Behind* as a visual inventory of discarded, decaying archaeological artifacts. To do so confuses the objects Buswell has photographed with the images he has created. As John Szarkowski observed in *Looking at Photographs*,

> The object [of a photograph] is raw material, not art, and it is the nature of the artist's adventure to recast this material under the pressure of his own formal will, transforming it into something distinct from what it was. Nevertheless, his choice of the particular dross that he will spin into gold is an important matter, for his raw material is both his collaborator and his adversary. (John Szarkowski, *Looking at Photographs: 100 Pictures from the Collections of The Museum of Modern Art* [New York: Museum of Modern Art, 1973], 156)

More than forty years ago, Richard Buswell chose the relics of Montana's past as his raw material. Much as James Joyce mined the sites and sounds of Dublin to create the worlds of Stephen Dedalus and Leopold Bloom, Buswell found in the abandoned mines, ranches, and homes of early Montana the stuff on which to train his lens. Over time, in five books, he has sharpened his focus, moving from panoramic vistas of abandoned buildings amid enduring natural landscapes to meticulously composed, tightly framed depictions of natural and man-made objects against stark black backgrounds, absent external referents. In so doing, he shifts our attention from the purpose or utility of his subjects to the form and structure of his pictures. Rooted though they are in Buswell's experience as a lifelong Montanan, the photographs in this book are no more (or less) "about" Montana than *Dubliners*, *A Portrait of the Artist as a Young Man*, or *Ulysses* are "about" Dublin.

Like one of his muses Georgia O'Keeffe, Buswell encourages us to ponder shapes, shades, and the patterns they make. *What They Left Behind* is not a coffee-table book to casually flip through; it is full of photographs that demand, but also reward, extended consideration. If we look closely, we no longer see the skin of a rattlesnake. Instead we encounter a remarkable pattern of uniformly shaped, precisely spaced arrowheads or mountain peaks whose varied tones create remarkably fluid visual fields for our contemplation. Two white spirals intersect to create a diamond-like design that calls to mind the double helix of DNA. Flanking the diamonds, gray-tipped cones flow in diagonal lines like the helmets of medieval warriors marching to battle or the miters of bishops processing into a cathedral.

A picture of three mine bits provides a different perspective on implied motion. Using a raking splay of light to illuminate the three bits, Buswell draws our attention to the points at which the edges of the bits disappear into the all-enveloping black background, forming alternating crescents of light and dark. Our eyes trace the elegant path of the edges into and out of the darkness, much as we might follow the form of a friend descending a spiral staircase.

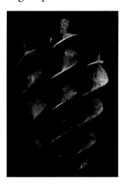

In a close-up of two crosscut saws, Buswell plays with light to create a positive void, a black space with undulating borders that resemble the shores of an inland sea photographed from the sky; the pits of corrosion on the surface of the saw blades call to mind the hills and valleys we detect from above as we fly cross-country at 30,000 feet. A similar presence of absence appears in the image Buswell crafts from a decaying skull, where worn and fractured bones frame an inky escape beyond decay; an escape that might lead to the nothingness of a black hole.

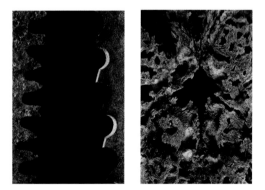

Buswell delights in exploring the geometry of nature and space: the ocular arcs of a decorated headboard, of a doll's hip sockets, or a twin-bulbed electrical socket; the angular division of space by the fraying spokes of a wheel or by wooden spindles that call to mind the decorative pointers of a compass rose; the wavelike pattern of growth rings on a knotty board; the mirrorlike symmetry of skeletal forms, from a cow pelvis, to a beaver skull, to the spine and ribs of an unidentified animal.

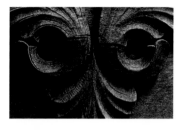

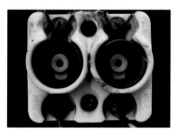

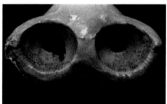

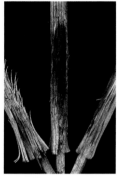

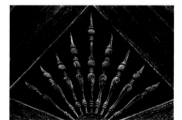

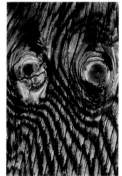

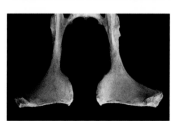

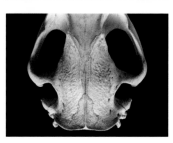

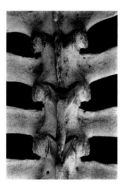

Whether humorous or austere, Buswell's images serve as visual metaphors, as analogies made manifest. Like a poet or novelist, he distills the formal qualities of the objects he photographs to make us aware of the "likeness" of discrete things and to encourage us to recognize the shared beauty that lies beneath them. As O'Keeffe did with the flora and fauna of Texas and New Mexico, Buswell extracts the distinctive characteristics of particular objects from Montana's past to reveal patterns that connect them to each other and to other everyday objects of life. He employs the frame of his lens and the limited spectrum of black-and-white film to pare the objects of his study to their formal core. His lean, unembellished images enable, indeed drive, his audience to make imaginative associations across the range of their personal experience, whether or not they have ever been to Montana or know anything about its history.

Despite their connection to objects from Montana's past, Buswell's explorations of form and tone are, in an important sense, ahistorical. They reveal and explicate essential attributes that persist outside time. Paradoxically, many of his photographs, even his most formal, are about time, especially our perception of its passage. It is hard to imagine, for example, that anyone could contemplate Buswell's photograph of the tattered cloth and frayed cords of a long discarded tire and not imagine what it once was (clad in rubber), how it was used (on a truck, a tractor, or automobile?), and what brought it to its current state (too many trips over unpaved country roads?).

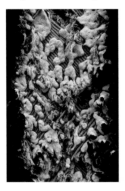

Much has been said and written about photography's ability to freeze time, to capture a decisive moment, and to preserve the ephemeral instant forever. Buswell does not seem to have much interest in making that sort of photograph. The objects of his study, the things he chooses to photograph, are standing still. They are quiet, the remnants of events that happened decades ago. But those objects are not timeless. As captured by Buswell, their surfaces exhibit their histories and prophesy their futures.

A stack of receipts fills the picture frame, making it virtually impossible to gauge the dimensions of the pile. Like a sedimentary rock, the layers of paper testify to the passage (and the pressure) of time and to the challenge of retrieving the past. Imagine the work required to find any particular financial transaction! The beautiful, sweeping curves of the spout of a water pitcher cannot divert our eyes from the many chips that mar its surface or the grime and dust that cling to it. An image of wooden piano keys reveals not only the craftsmanship that created them but also the accumulated wear and tear that has fractured the wood and silenced the piano. Like the glaze on the spout, the wood of the keys seems unlikely to be repaired or repurposed. We can visualize their future.

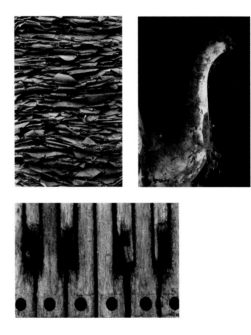

In earlier books, Buswell often leavened his contemplation of time's inexorable impact by setting his images in nature, contrasting the rise and fall of Montana's pioneer settlements with the annual cycle of rebirth that shapes our world. *What They Left Behind* is a more somber book that compels readers to contemplate our personal mortality. Its photographs

evoke "memories" of lives past, but they also allude to what lies ahead for all of us. Eight elk teeth gleam as if new, but they no longer form the mouth of a living animal. They are attached to bone shorn of all muscle. A print of desiccated, decaying, dried fish spawns thoughts not only of them swimming in the cold, fresh waters of Montana's rivers but also of the men or women who caught them and ostensibly preserved them for nourishment. What interrupted that plan? What became of those people? What will become of us?

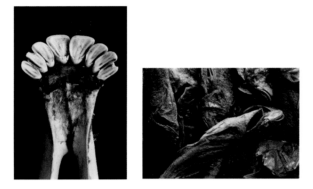

Many, indeed most, books about western ghost towns and historical artifacts abound in sentiment. They rely upon and manipulate our nostalgia for bygone days. They comfort us with the illusion that we can turn back and recover what has been lost. *What They Left Behind* confronts us with images that spur us to measure our days and remind us that time is a relentless, remorseless current that carries us onward despite our wishes to remain or return. Richard Buswell is not a morbid man, but neither is he an escapist. In a medical career that has spanned five decades, he has improved the quality of life of thousands of patients but has also learned about the transformations that mark lives, individually and collectively. His meditations on time are complex, equally tender and harrowing, intimately personal, and culturally astute.

A series of photographs of dolls exemplify the multiple layers of Buswell's artistry. His dolls are eyeless, colorless, and scarred by chips, cracks, and pockmarks. Discarded and decaying, devoid of decoration, they evoke the busts of fragmented Greco-Roman statues. Toys they may be, but they remind us of classical art and the shared human pursuit of beauty. They compress time and link us to men and women of another millennium. Unlike those ancient sculptures, ensconced in museums and isolated from most of our daily experience, the dolls also trigger more immediate, personal memories. As the toys of our youth, of our children's youth, they roll away the accretions of time and awaken recollections of innocent play when we were blissfully ignorant that our time was limited. Pondering them, we become acutely aware not only of their age but ours. The dolls seem to ask, "Where have you been? What have you done since you discarded us?" A left forearm and hand, missing its pinky finger, waves at us. Whether in welcome or farewell is undetermined and matters not; its bruised and broken form foreshadows our own demise, a message reinforced by an image of severed doll parts, piled upon each other in what resembles a mass grave.

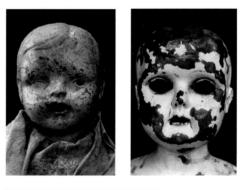

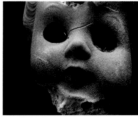

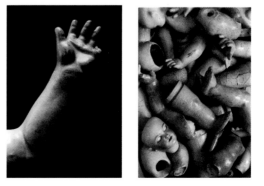

As all great photographers do, Richard Buswell disrupts our normal vision. His photographs of commonplace objects, presented in isolation absent their typical surroundings, interfere with our comprehension, forcing us to look again rather than allowing our minds to process unconsciously what appears before us. His stark, apparently simple images help us penetrate the superficial appearance of objects from Montana's past to contemplate the multiple, complex meanings that their histories and presence convey. And, perhaps, stir us to consider the things we will leave behind.

Ultimately, as with joy we take from a blues song or the performance of street musicians at a New Orleans funeral parade, the enjoyment we derive from Buswell's photographs lies less in their specific subjects or themes than in their compelling beauty and the skill they exhibit. Like a great athlete, actor, or musician, Buswell inspires our awe by his ability to use light, a lens, and silver salts to create images that capture our attention, delight our sight, and stimulate both our hearts and our minds. We and our descendants can be glad that they are among the things that he leaves behind.

—George Miles
William Robertson Coe Curator
Yale Collection of Western Americana
Beinecke Rare Book & Manuscript Library
Yale University, New Haven, Connecticut

INTRODUCTION

MANY OF US ARE drawn to the curious relationships between objects, their textures, the patterns they create, and the space within which they are visually arranged, whether accidental or intentionally designed. The relationship of objects can be emphasized by the contrast and the interaction of dark and light as well as their relationship to the pictorial positive or negative space. Notan is a Japanese design concept that involves the relationship of light and dark. In many of Richard Buswell's photographs, it is the play and placement of light and dark that creates the intrigue of the object. The notan inherent in these photographs provides the framework in which we can simultaneously experience the contours of *Spine and Ribs* (2014) centered in a staccato black rectangle and appreciate the cracked and porous texture of its surface.

> We put thirty spokes together and call it a
> wheel;
> But it is on the space where there is nothing that
> the usefulness of the wheel depends.
> We turn clay to make a vessel;
> But it is on the space where there is nothing that
> the usefulness of the vessel depends.
> We pierce doors and windows to make a house;
> And it is on these spaces where there is nothing
> that the usefulness of the house depends.

Therefore just as we take advantage of what is, we should recognize the usefulness of what is not.

—Lao Tse (Translated by Arthur Waley, *The Way and Its Power: A Study of the Tao Tê Ching and Its Place in Chinese Thought* [Boston, MA: Houghton Mifflin, 1935], 155)

This poem was written about two thousand years ago in China. The concept it expresses—that the emptiness, where the object is not, activates the object itself—is how I experience Richard Buswell's photography. The frame—in this case, the edge of the negative—is placed precisely as the artist intended. Studying the photographs thoroughly can give us a greater understanding of the relationships of the positive and negative spaces, leading to a more complete experience of the works.

I was first introduced to Richard Buswell's work when we featured the exhibition *Silent Frontier: Icons of Montana's Early Settlement* in 2006 and subsequently, in 2008, *Traces: Montana's Frontier Revisited* at the Nora Eccles Harrison Museum of Art at Utah State University in Logan. My most recent encounter was with the exhibition *Close to Home* hosted by Oklahoma State University Museum of Art in Stillwater in 2015. In all three instances, I experienced an immediate connection

with his aesthetic. He creates a modest yet eloquent statement through carefully selecting objects found in the debris of his personal paradise in the ghost towns of western Montana. I've had the privilege of walking some of the trails with him, exploring the world that has been his muse since childhood. Each time I am more impressed with his process of finding the elements he captures on film and what he does with them in the lens and in the darkroom. There is no doubt that his many years of discovery, among the obscure and remote locations around his ancestral home, have shaped his visual vocabulary. In this, his fifth publication, we have the opportunity to see his evolving relationship with his subject.

Because so much has expanded in the world of photography with the advent of digital technology, I feel it is necessary to mention the importance of Buswell's choice of the silver gelatin print process and the type of discipline it requires. There is a synergy between Buswell and this process that is inherent in his artwork. When I look at his photographs, I remember my days as a student learning photography. I recall the hours I spent developing film in the dark, using an enlarger to expose the negative onto the paper, and the time spent developing each individual print in the developer, stop, fixative, and water baths. There is much practice and skill required to create the masterful prints we enjoy.

What first captures my eye are the shapes created by the placement of the object within the rectangle. With careful inspection, I see natural forms distilled into stark geometries arranged in such a way that provides an element of theater. His photographs become minimalist art that excludes the pictorial, illusionistic, and narrative in favor of the literal. Many of these photographs remind me of shards of ancient Greek or Roman vessels that provide evidence of past cities and civilizations. Some images are taken in situ. For other objects, he takes them back to the studio for careful alignment and skillful illumination. The old mines, abandoned structures, and fragments of the lives of humans and animals are transformed through his intimate familiarity with Montana and his practiced eye for the sublime.

It is important to spend time with these photographs. The more I look, the more I become absorbed in the images themselves. The viewer adds their own meaning to what they see. In many of the photographs, often it is what is not included, and not just the object, that creates the intrigue.

We bring with us our own personal narratives, and long looking can often provide the path to greater connection with a work of art. It may be helpful to understand that Buswell sometimes goes out into the field for several days without capturing a single image. Instead, he is in search of the potential image to which he will return at the proper moment. His time in the field is therefore a significant part of his creative process, leaving only the finishing touches to the darkroom.

With this fifth collection of photographs, we can enjoy the evolution of Richard Buswell's imagery of intimate and abstracted vignettes. Crisp, intentional, and profoundly beautiful found objects are here for us to discover. Many may ask, "What is it?" Remarkably, it is difficult to figure out what we see; yet we are compelled to look more carefully. In the end, it doesn't matter. I hope you will find your careful study of the works illustrated in this volume rewarding. Although we may not understand what we are looking at, we can enjoy the eloquent abstract vocabulary of Richard Buswell. His art is worthy of opening ourselves to fully experience *What They Left Behind: Photographs.*

—*Victoria Rowe Berry*
Director
Oklahoma State University Museum of Art
Stillwater, Oklahoma

PLATES

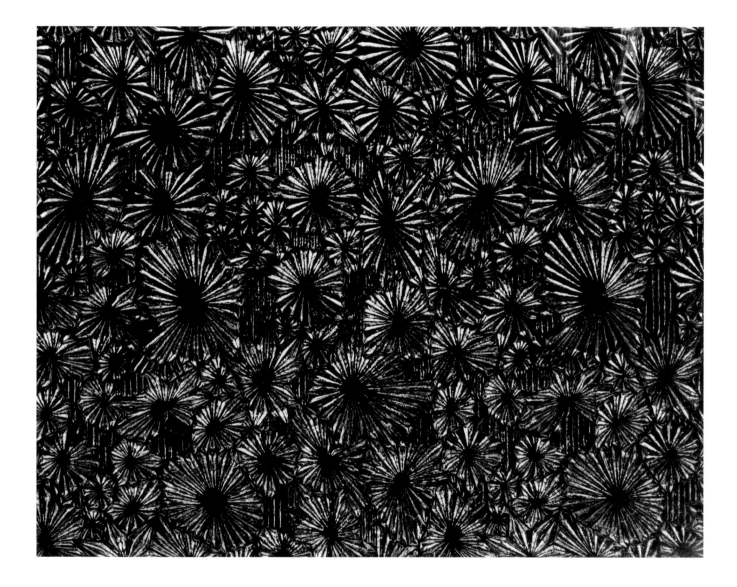

PLATE 1. *Church Window,* 2014

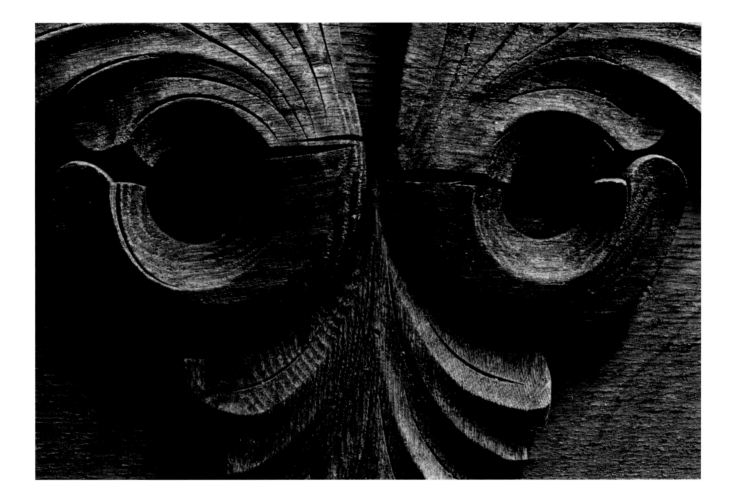

PLATE 2. *Headboard,* 2013

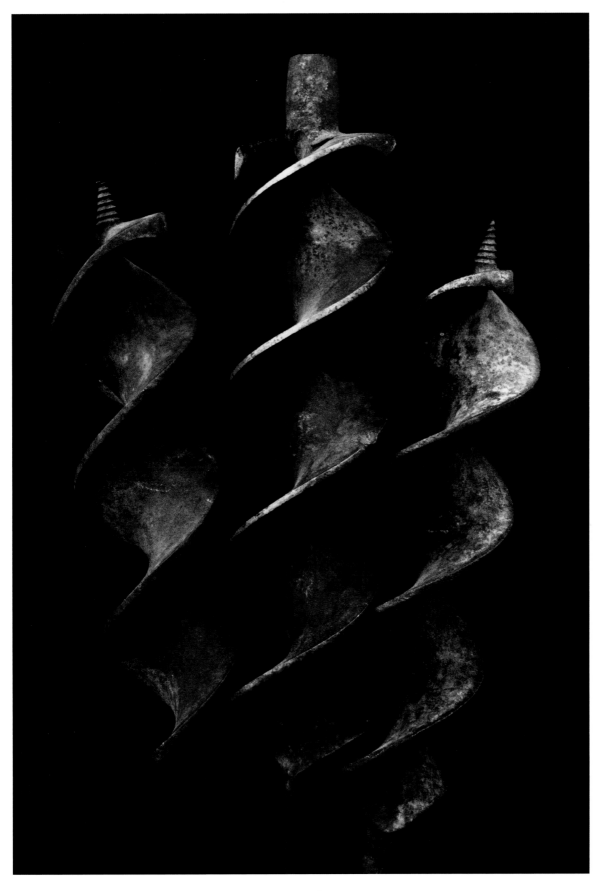

PLATE 3. *Mine Bits*, 2013

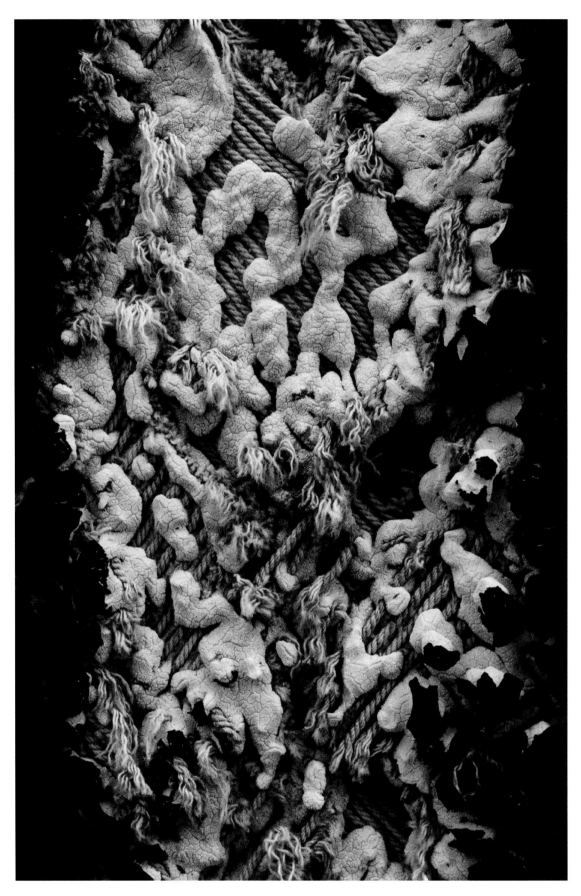

PLATE 4. *Tire No. 2,* 2013

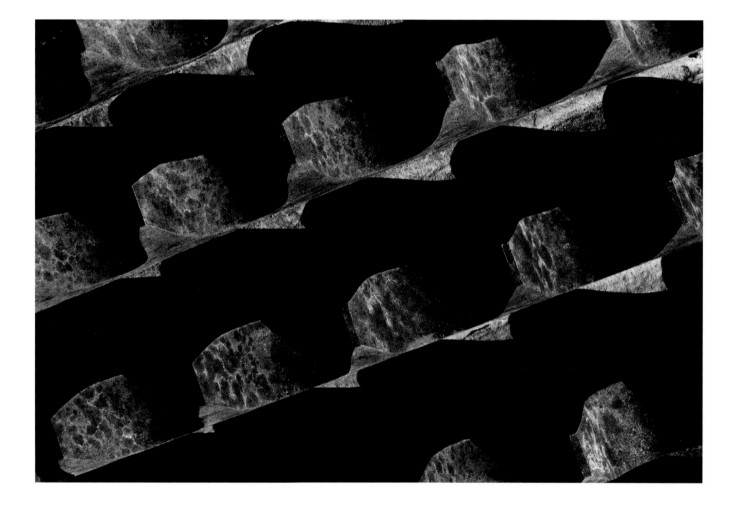

PLATE 5. *Wheel Cleats*, 2013

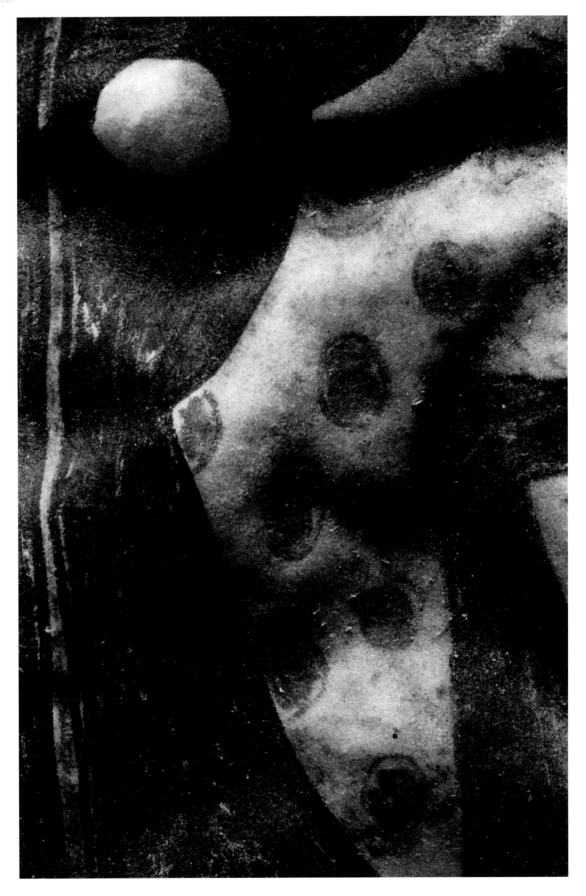

PLATE 6. *Abstract No. 1*, 2015

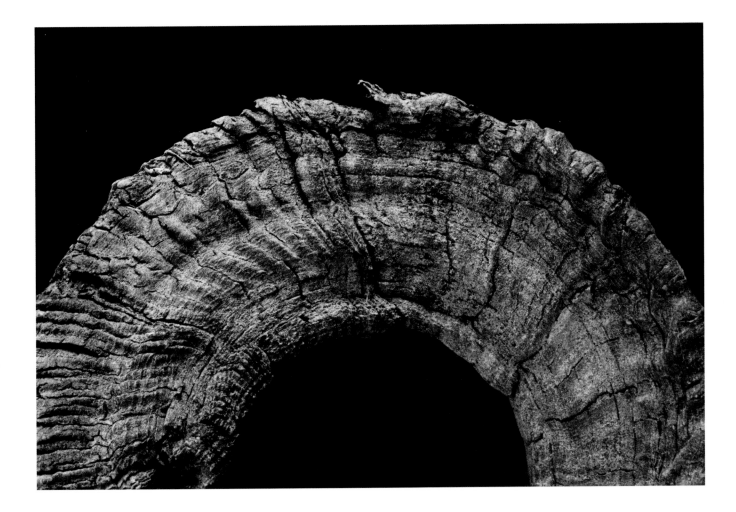

PLATE 7. *Ram's Horn*, 2012

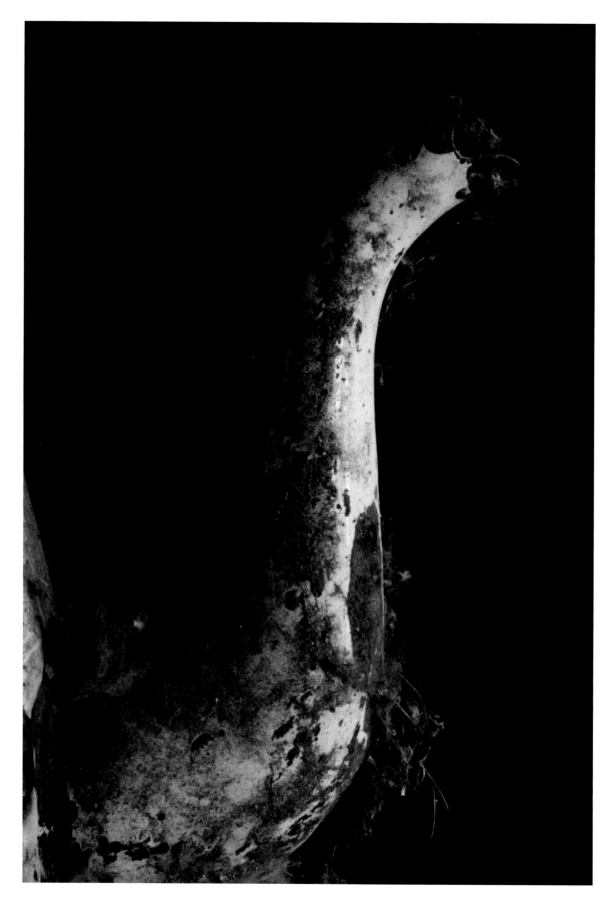

PLATE 8. *Spout*, 2012

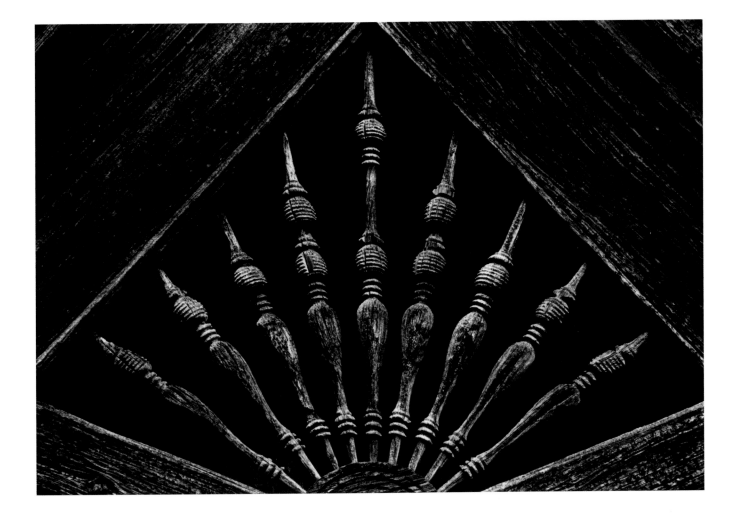

PLATE 9. *Spindles*, 2012

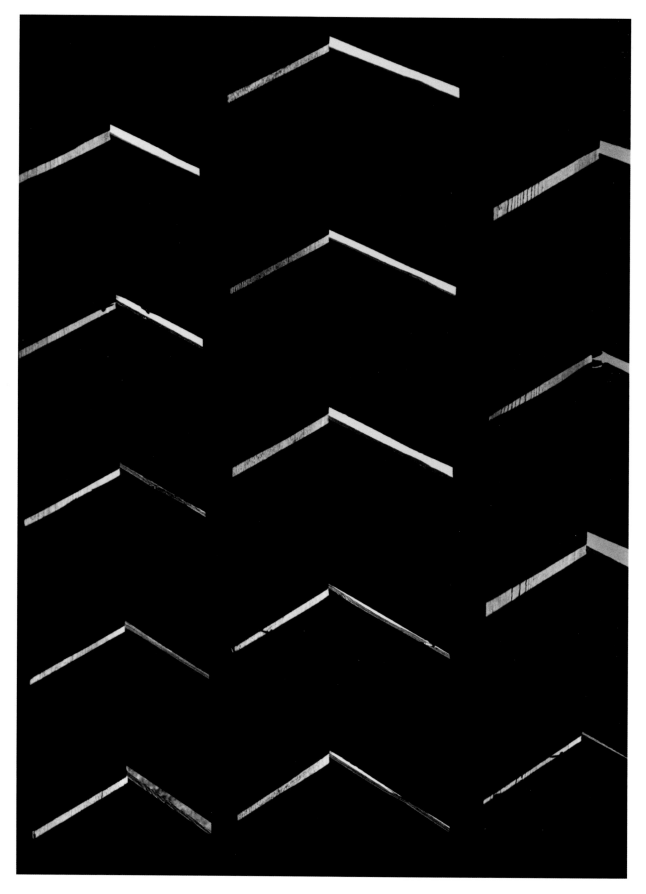

PLATE 10. *Mill Ceiling*, 2012

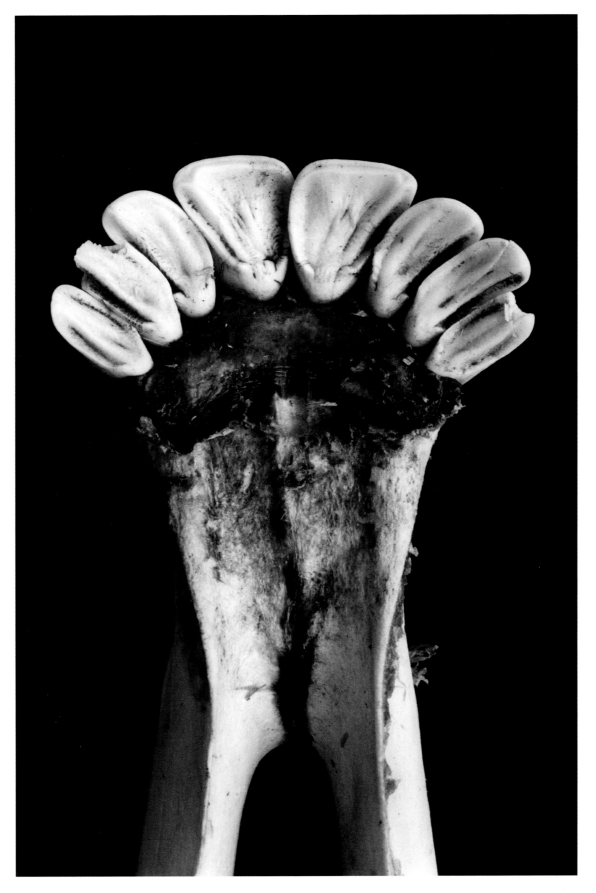

PLATE 11. *Elk Teeth*, 2012

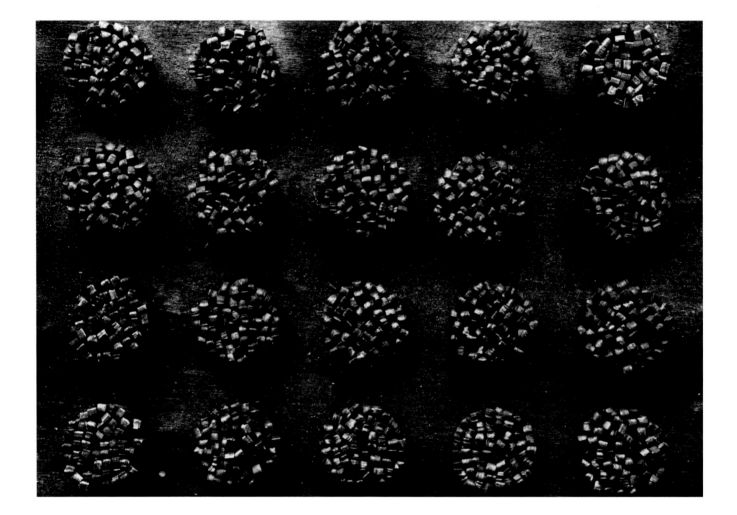

PLATE 12. *Player Piano Pins*, 2013

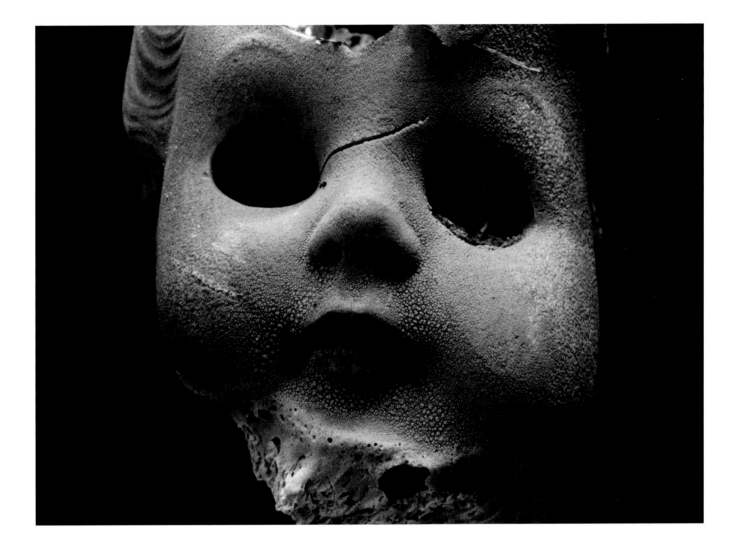

PLATE 13. *Doll Face*, 2013

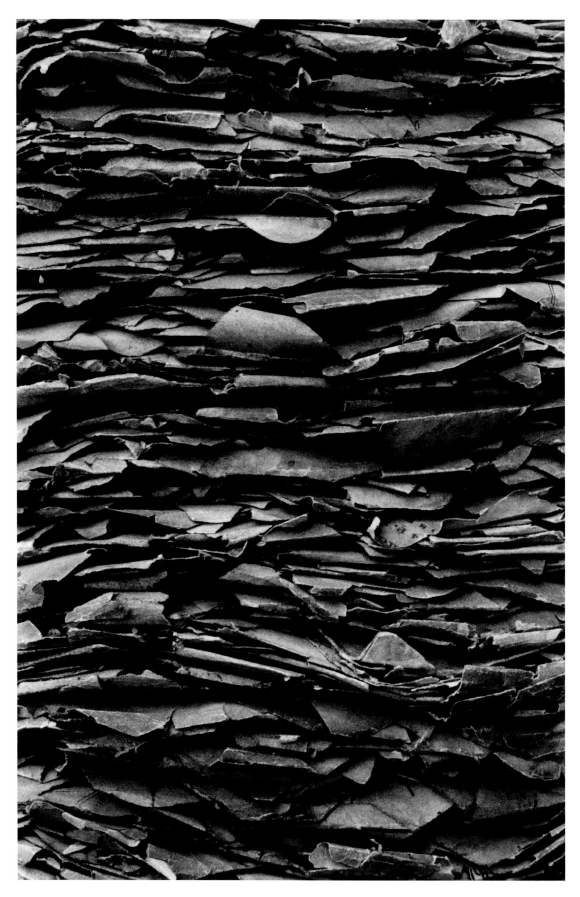

PLATE 14. *Receipts*, 2015

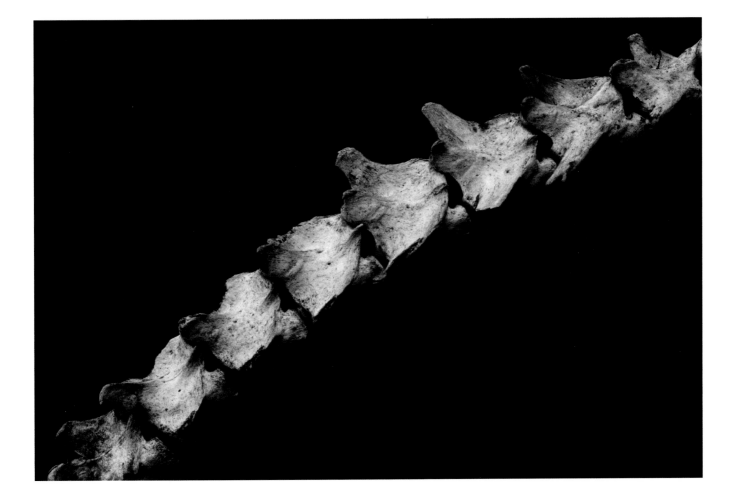

PLATE 15. *Calf Spine*, 2014

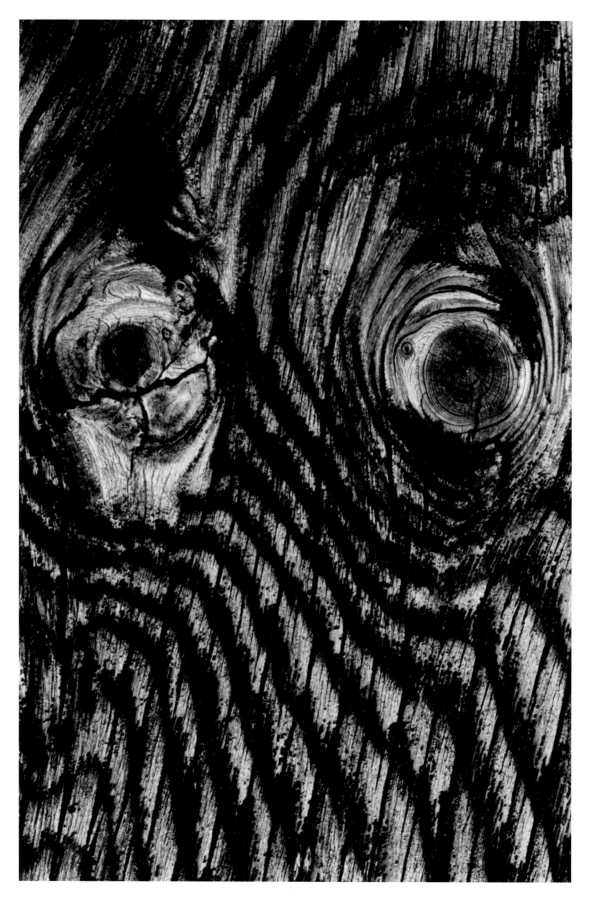

PLATE 16. *Knots No. 1*, 2015

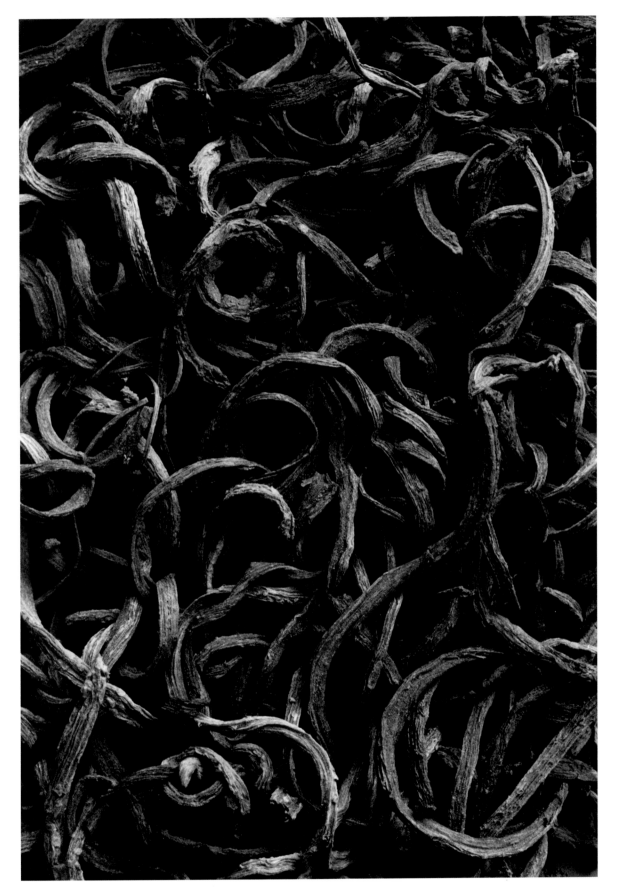

PLATE 17. *Rat Tail Noodles*, 2014

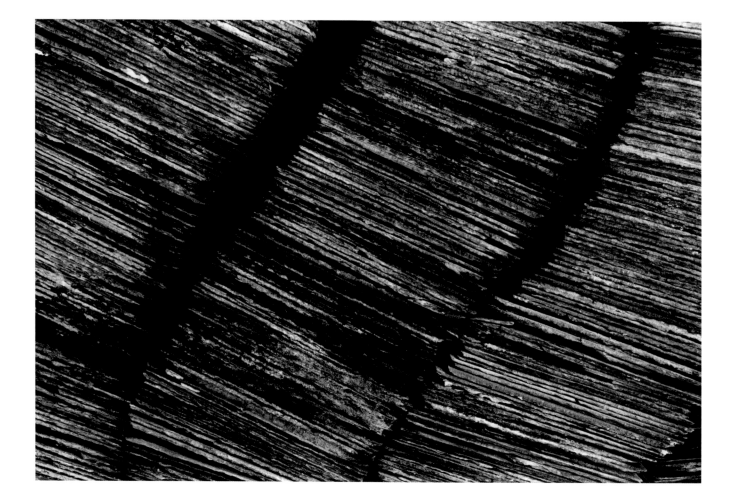

PLATE 18. *Slate Shingles*, 2014

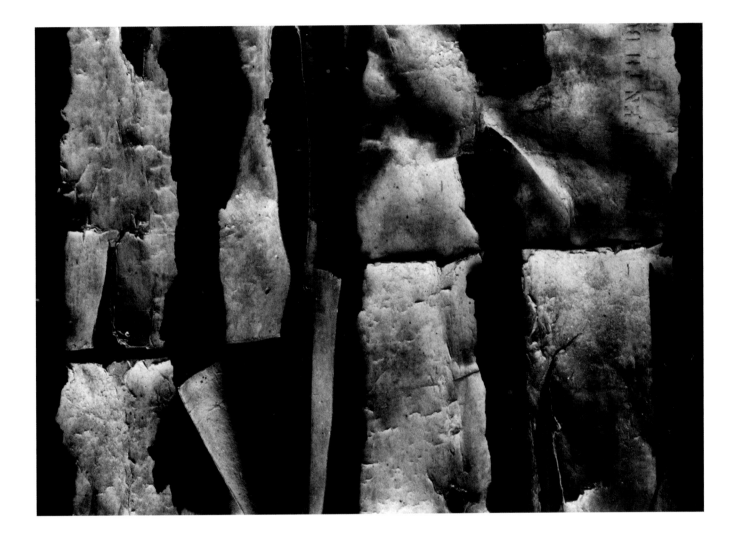

PLATE 19. *Cardboard Siding*, 2013

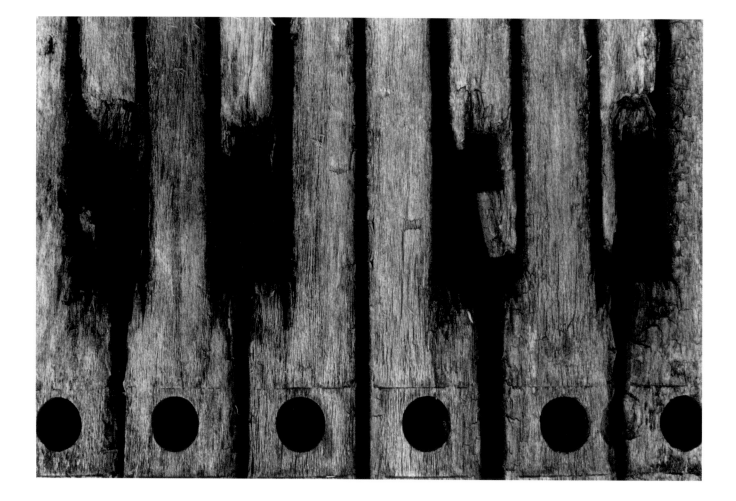

PLATE 20. *Piano Keys*, 2014

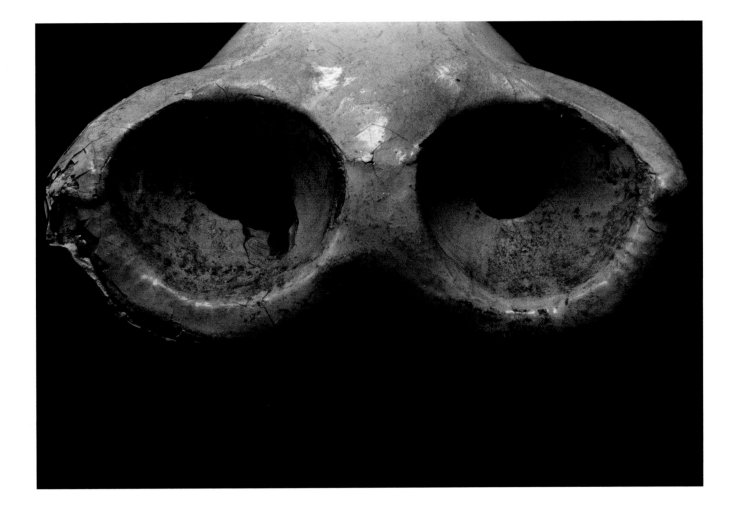

PLATE 21. *Hip Sockets*, 2015

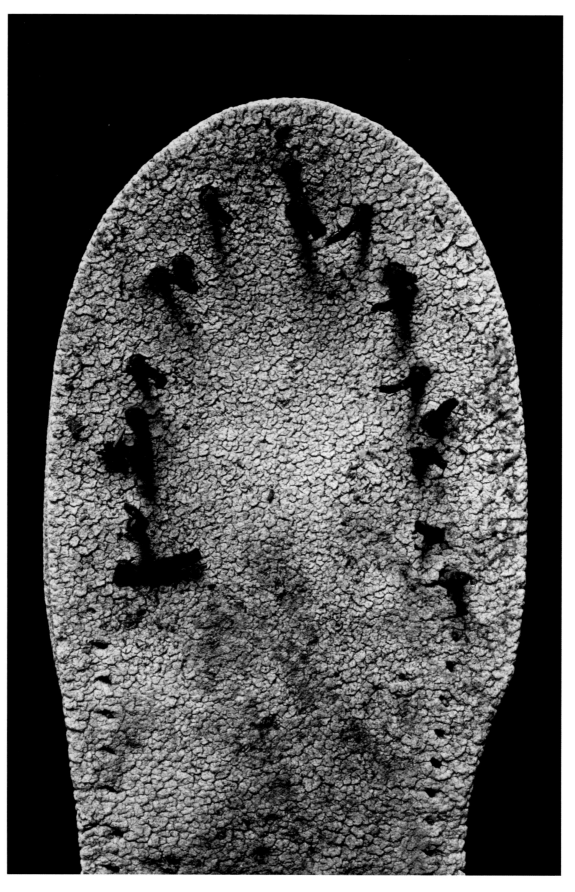

PLATE 22. *Sole*, 2013

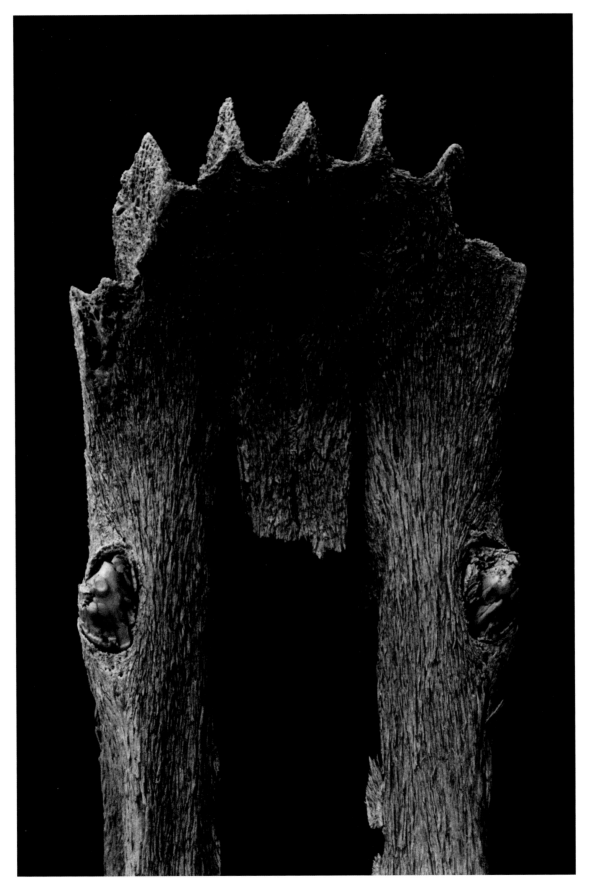

PLATE 23. *Mandible, Interior*, 2014

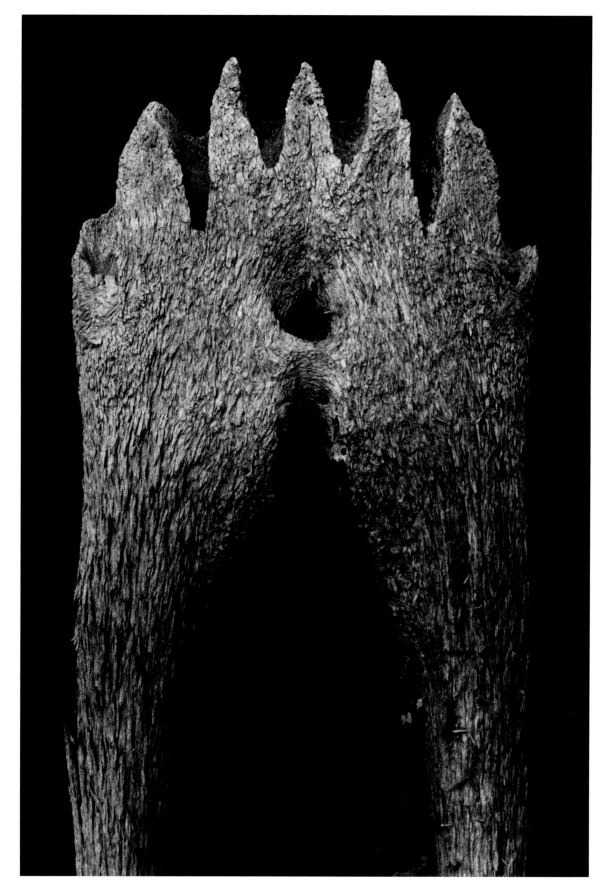

PLATE 24. *Mandible, Exterior*, 2014

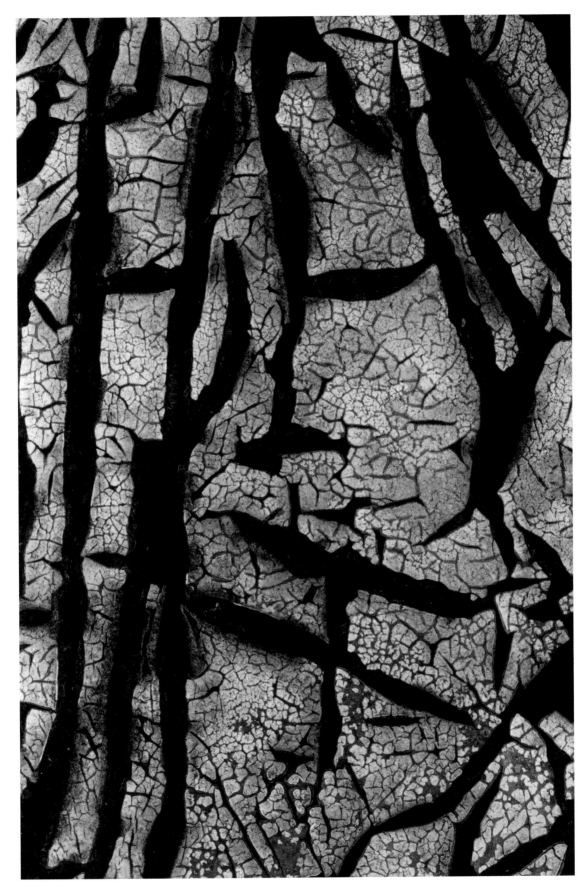

PLATE 25. *Linoleum No. 2,* 2015

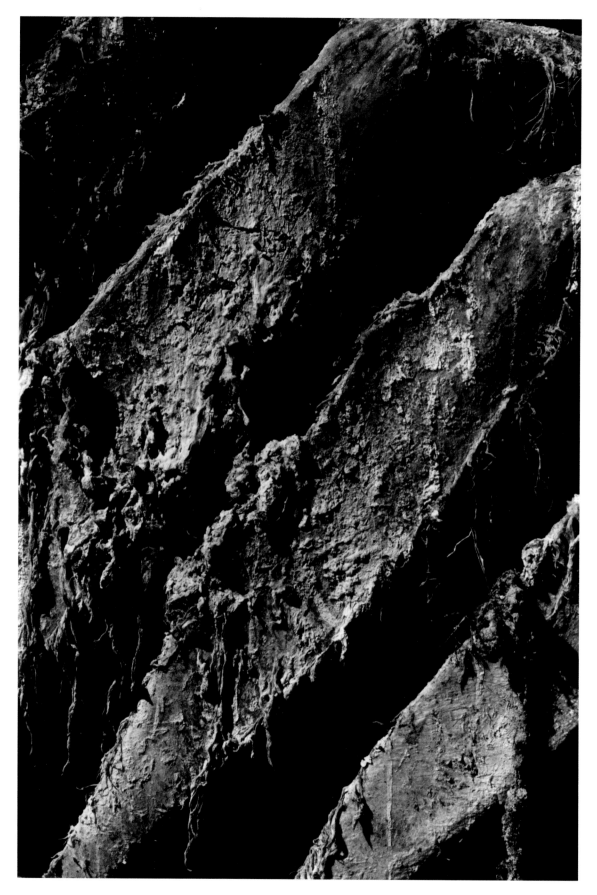

PLATE 26. *Ribs*, 2012

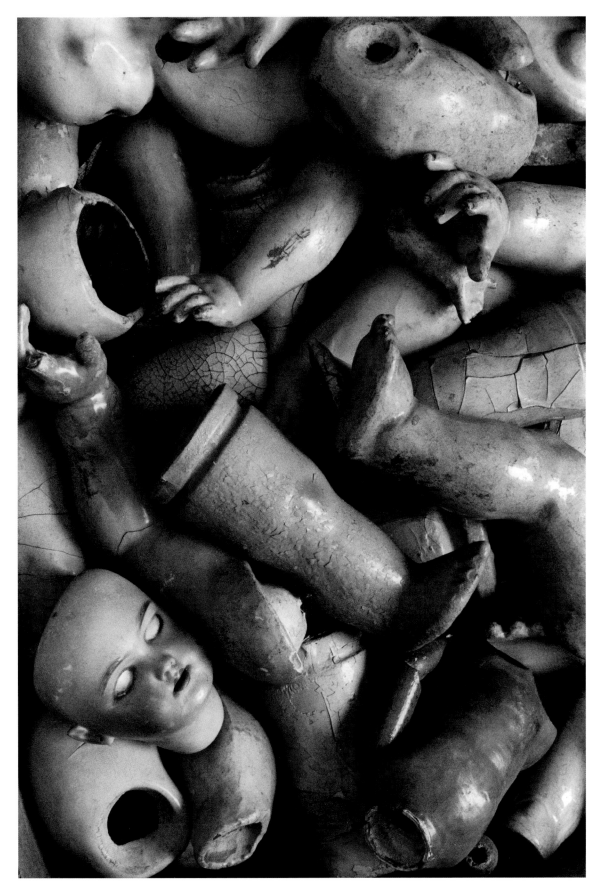

PLATE 27. *Doll Parts*, 2014

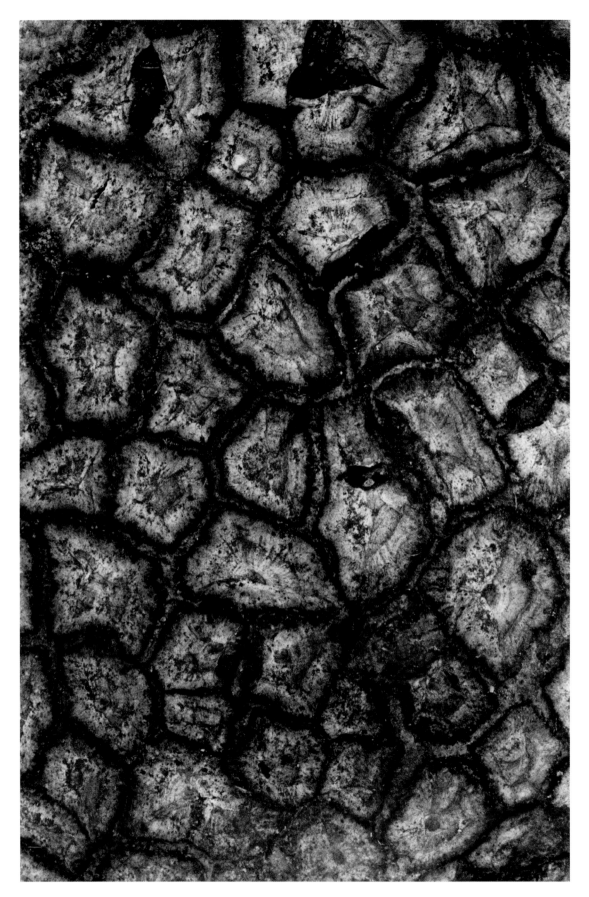

PLATE 28. *Mushroom*, 2015

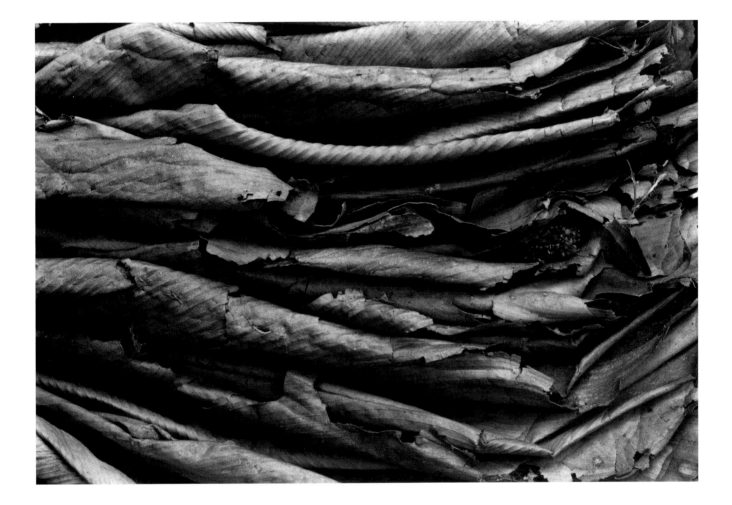

PLATE 29. *Tobacco*, 2014

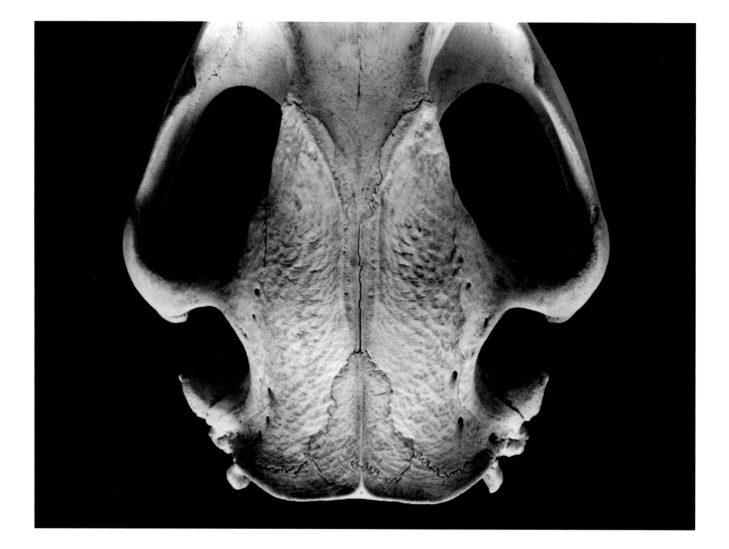

PLATE 30. *Beaver Skull*, 2012

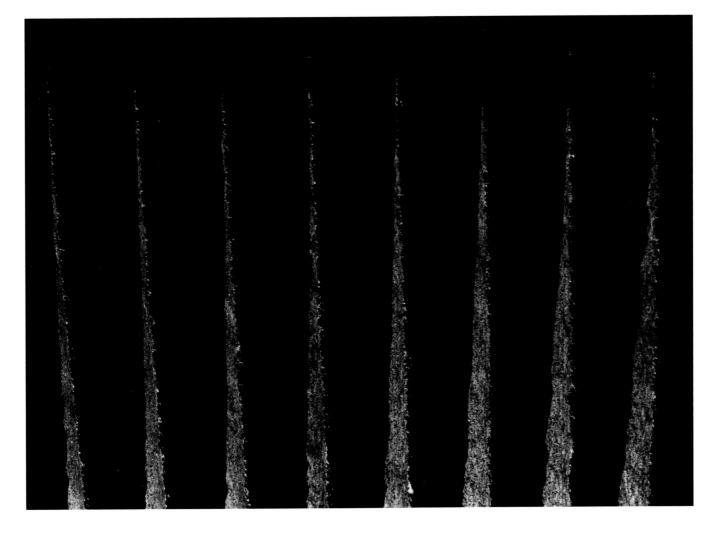

PLATE 31. *Hoist Drum*, 2013

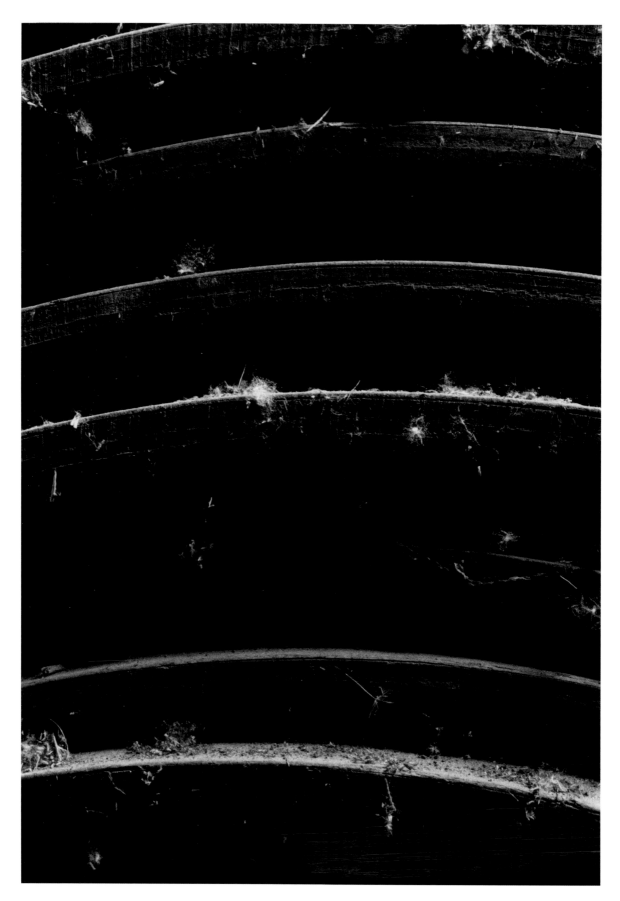

PLATE 32. *Stacked Chairs*, 2012

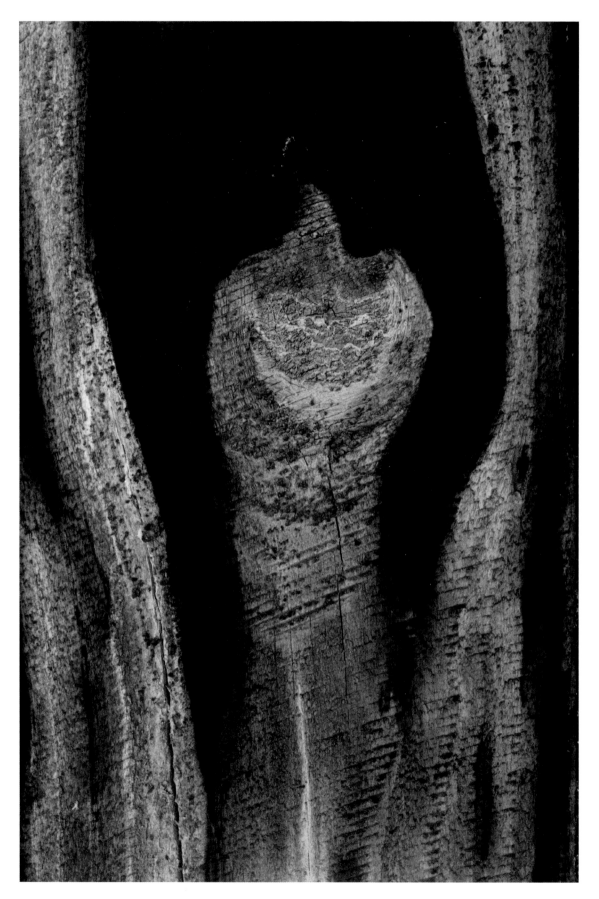

PLATE 33. *Knot Pattern*, 2012

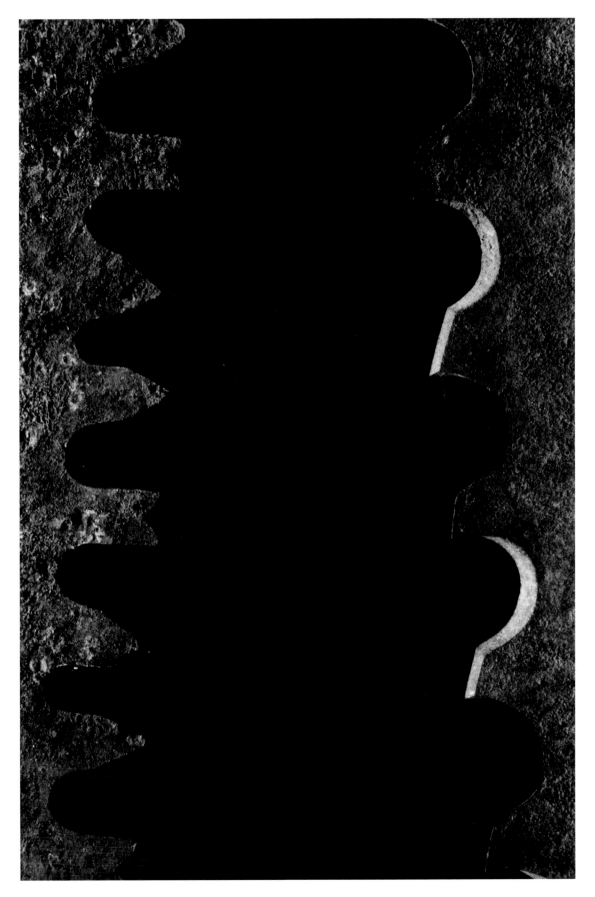

PLATE 34. *Cross Cut Saws*, 2013

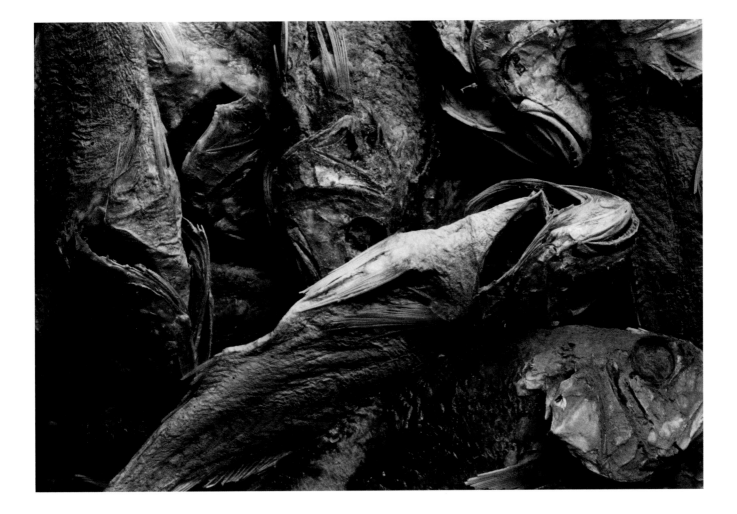

PLATE 35. *Dried Fish*, 2014

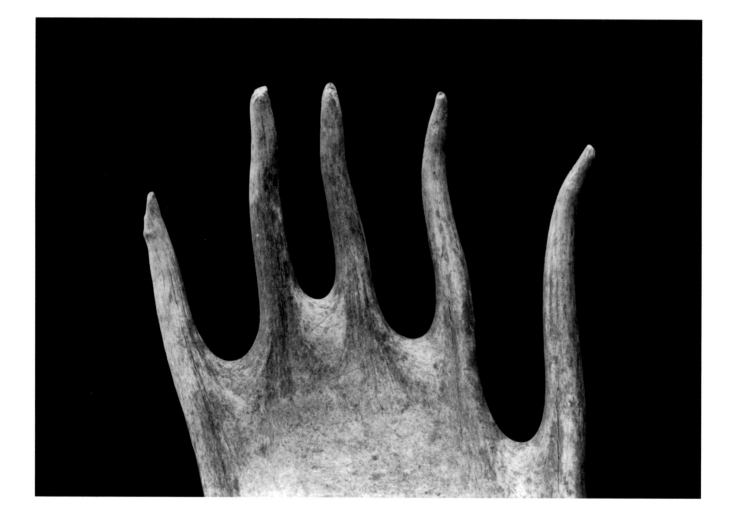

PLATE 36. *Moose Antler*, 2012

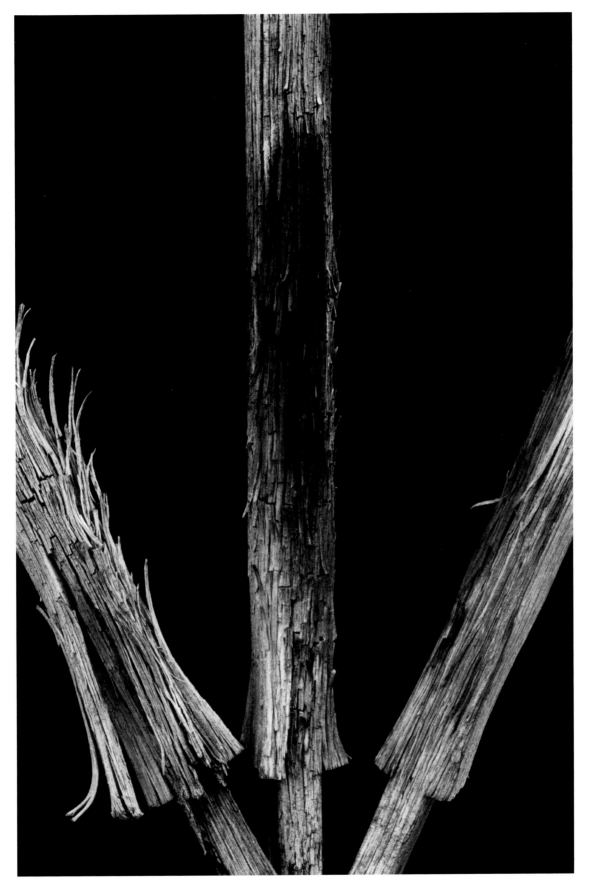

PLATE 37. *Spokes*, 2014

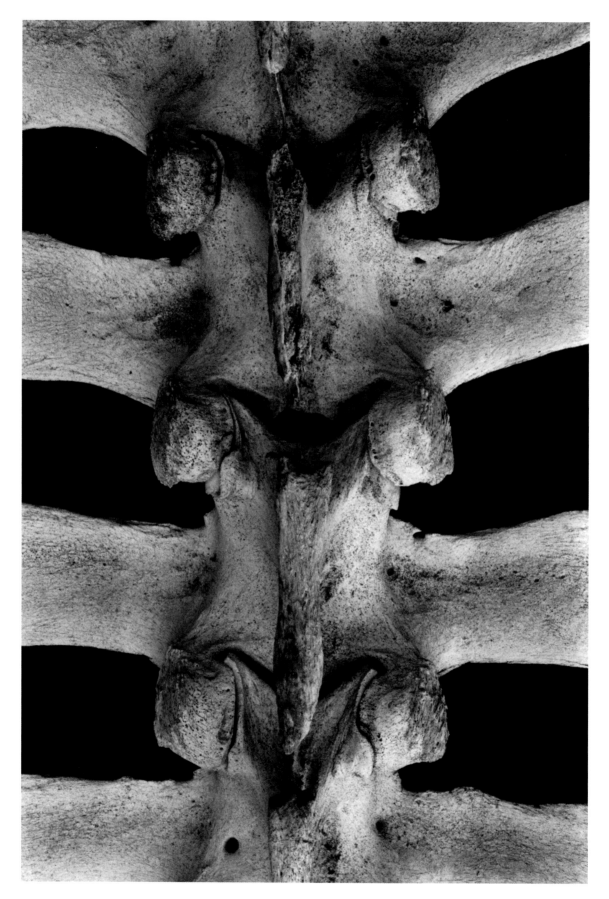

PLATE 38. *Spine and Ribs*, 2014

PLATE 39. *Assay Plate*, 2014

PLATE 40. *Mill Floor*, 2012

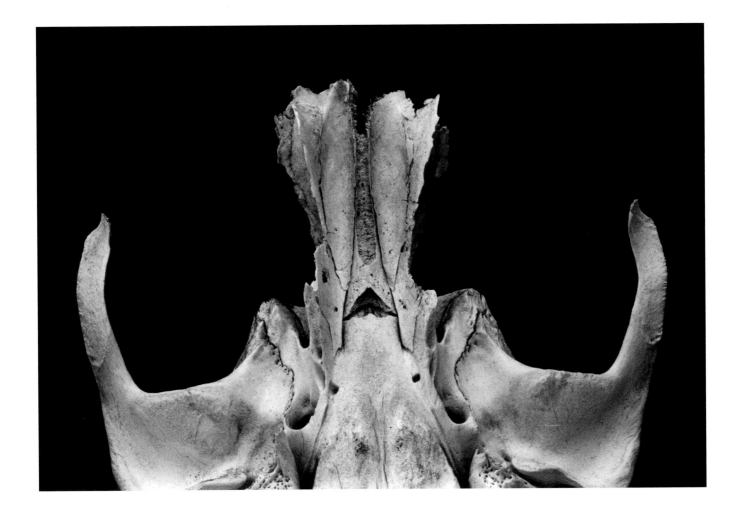

PLATE 41. *Bone Series No. 4,* 2015

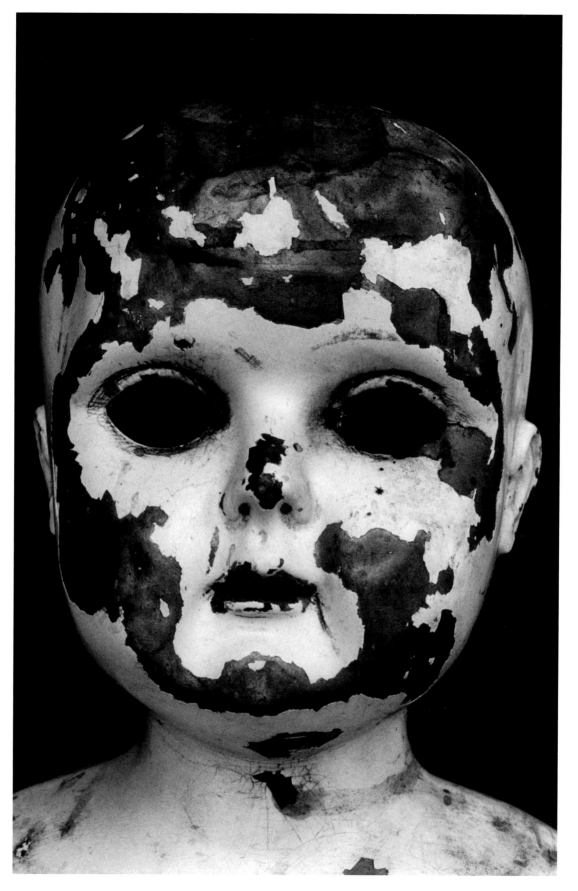

PLATE 42. *Doll Face No. 2*, 2015

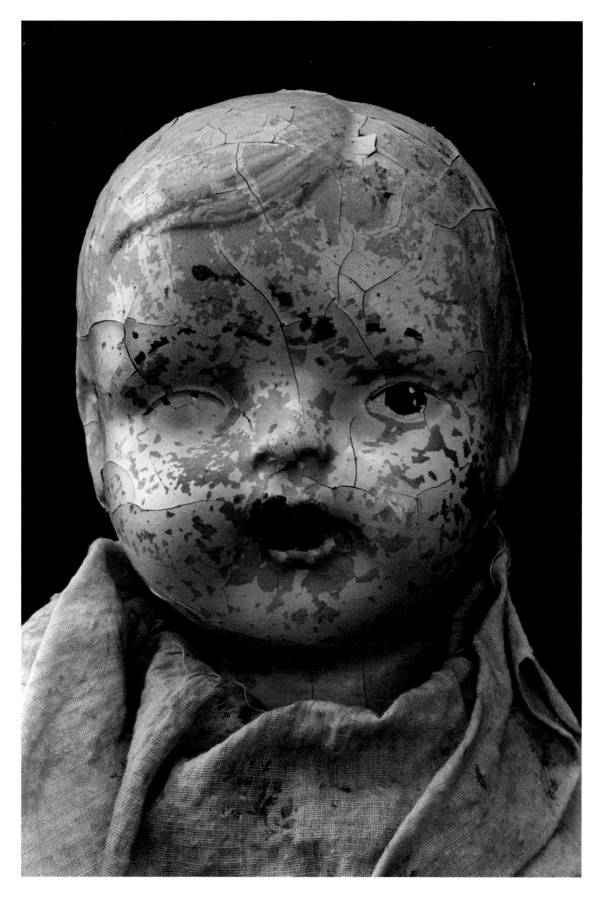

PLATE 43. *Doll Face No. 3*, 2015

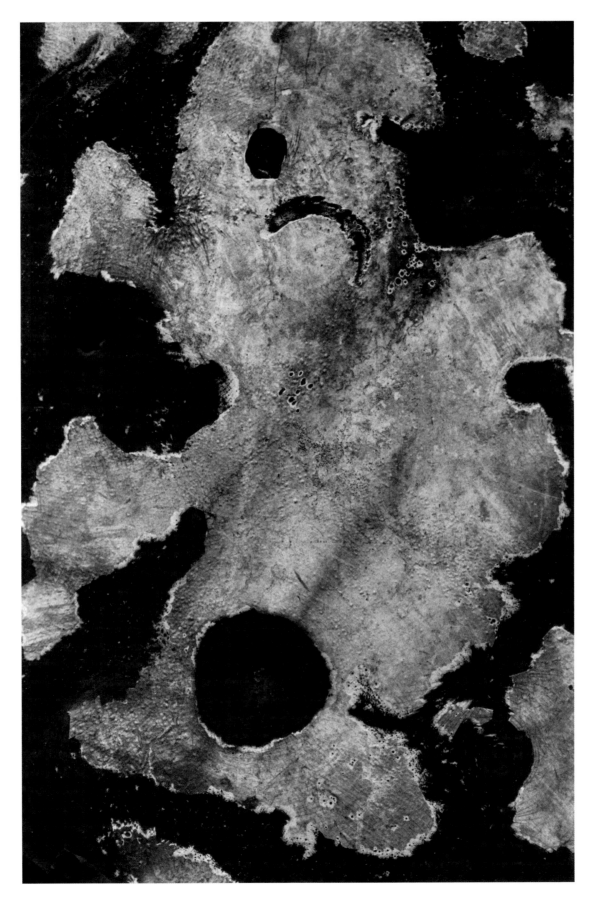

PLATE 44. *Sheet Metal*, 2012

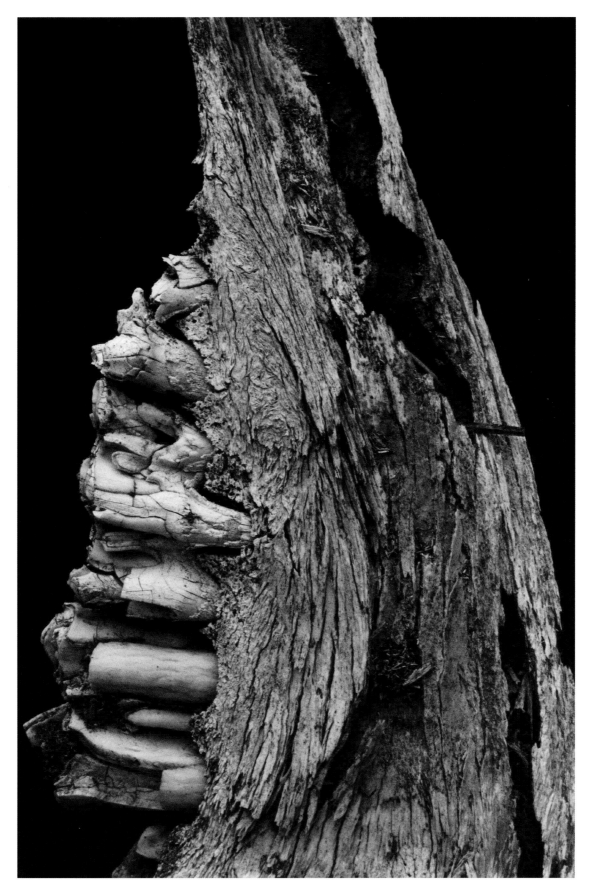

PLATE 45. *Cow's Mandible*, 2014

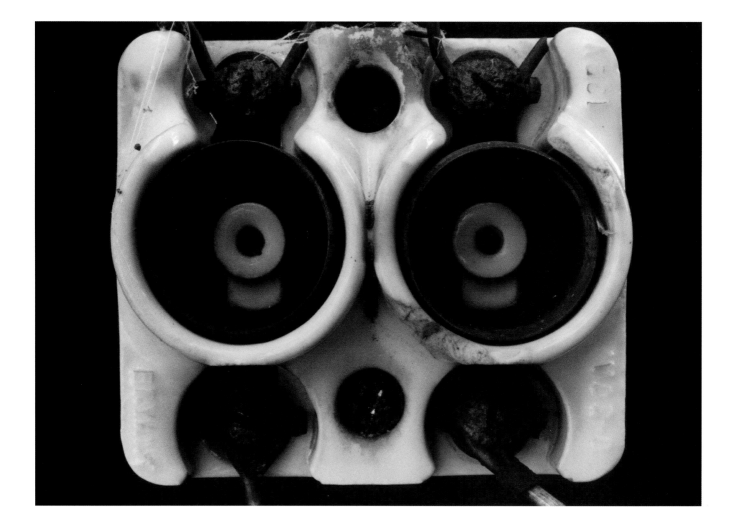

PLATE 46. *Bulb Sockets*, 2013

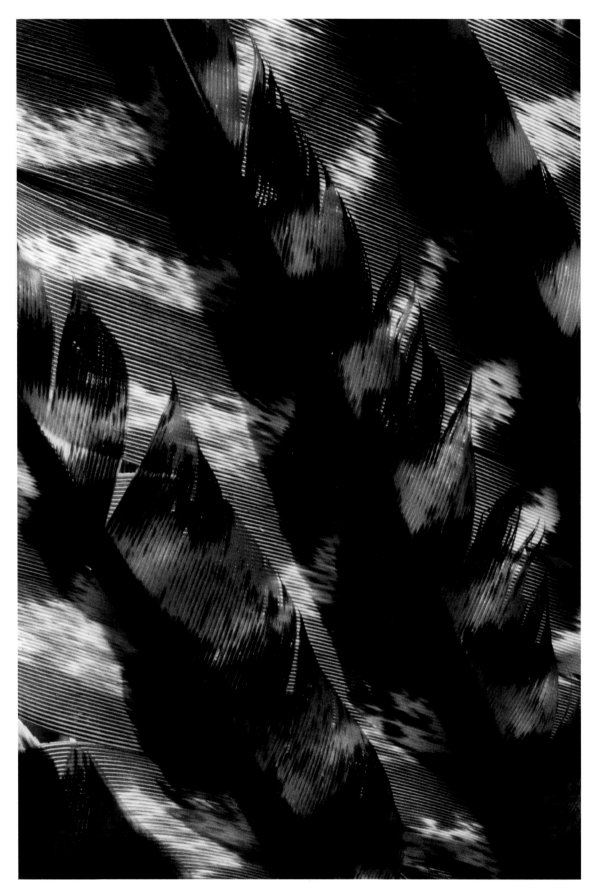

PLATE 47. *Feathers*, 2014

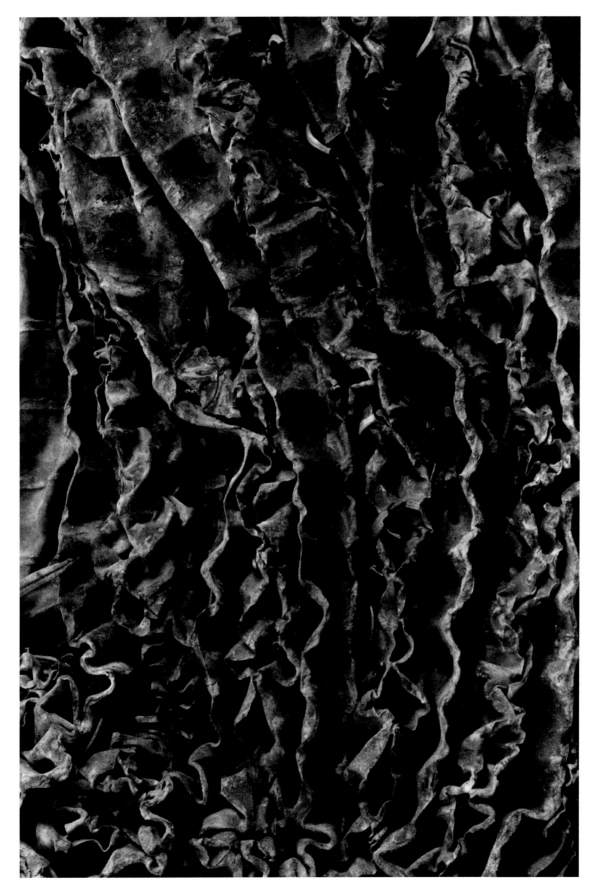

PLATE 48. *Crushed Radiator*, 2012

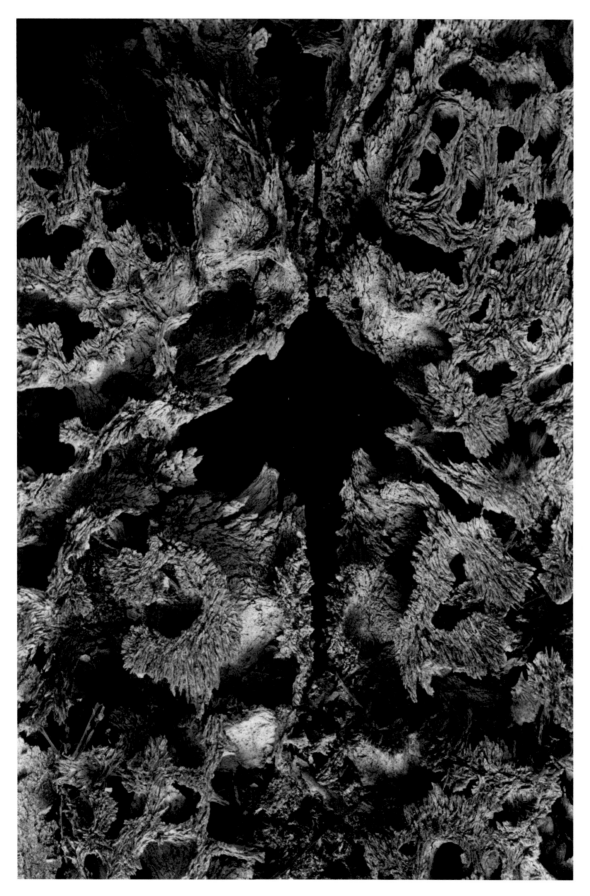

PLATE 49. *Decaying Skull*, 2012

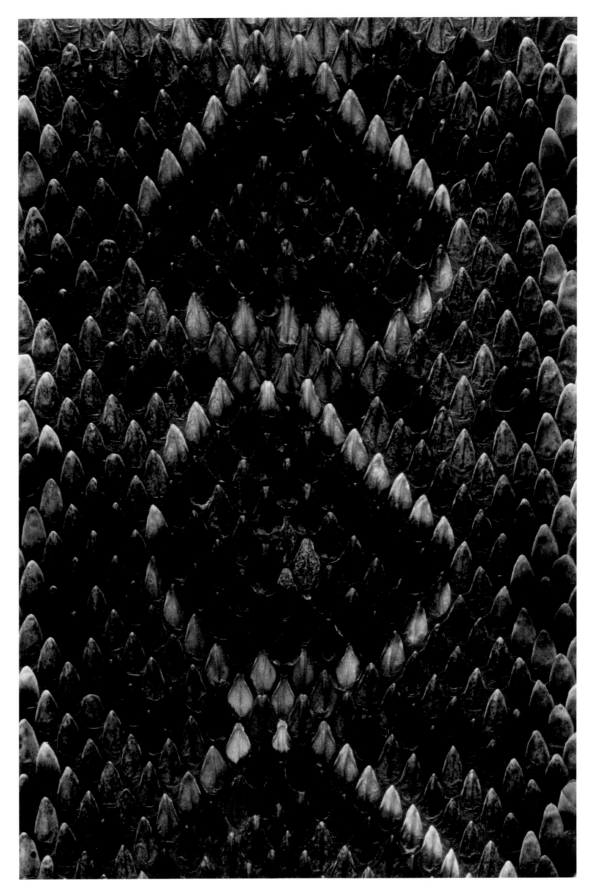

PLATE 50. *Rattlesnake*, 2013

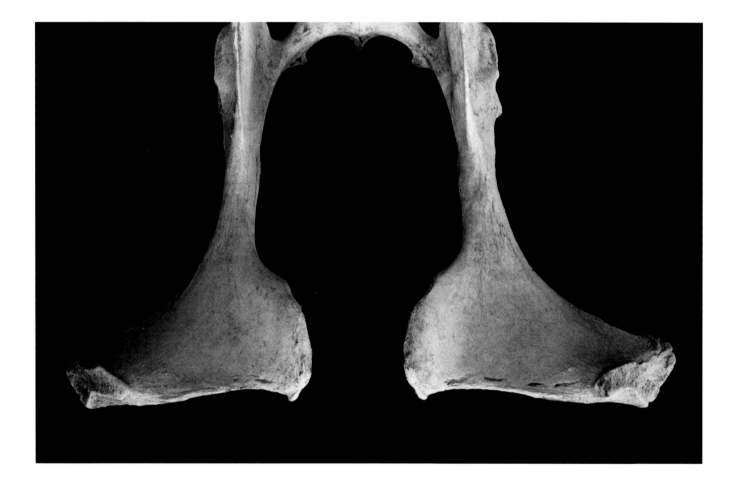

PLATE 51. *Cow's Pelvis*, 2012

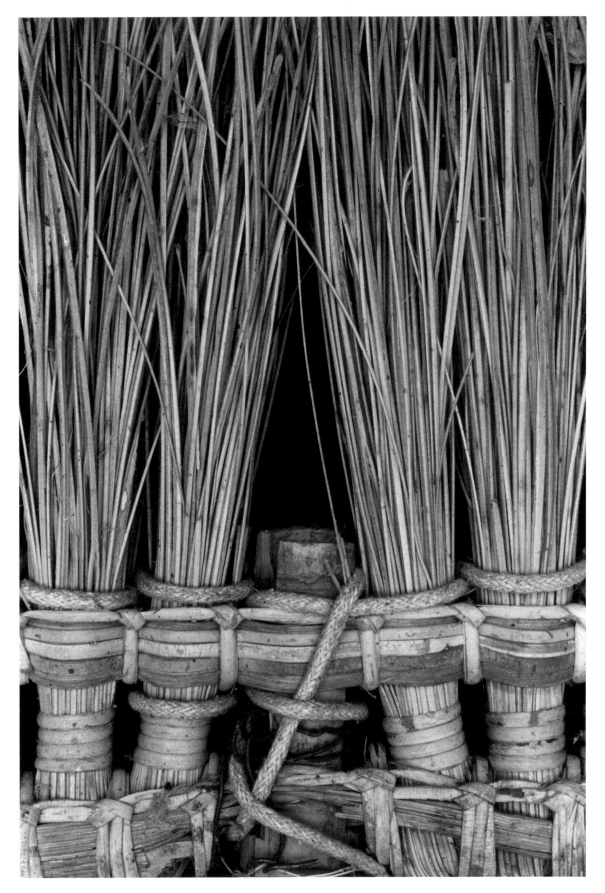

PLATE 52. *Broom*, 2014

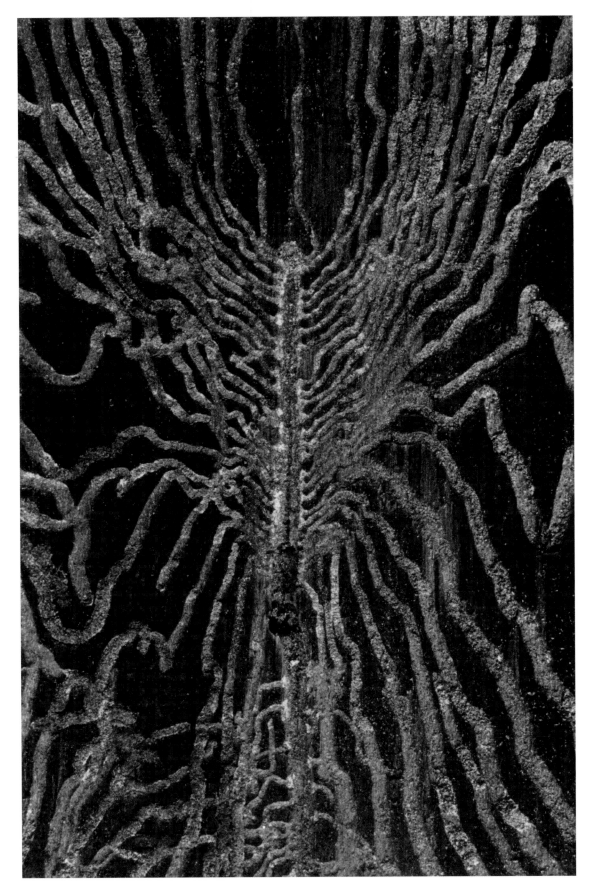

PLATE 53. *Beetle Tracks No. 1,* 2015

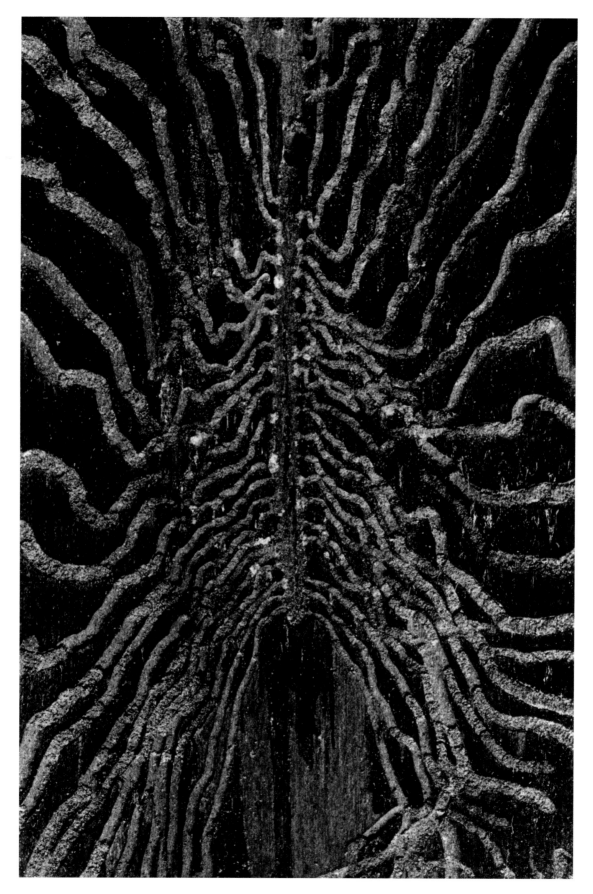

PLATE 54. *Beetle Tracks No. 2,* 2015

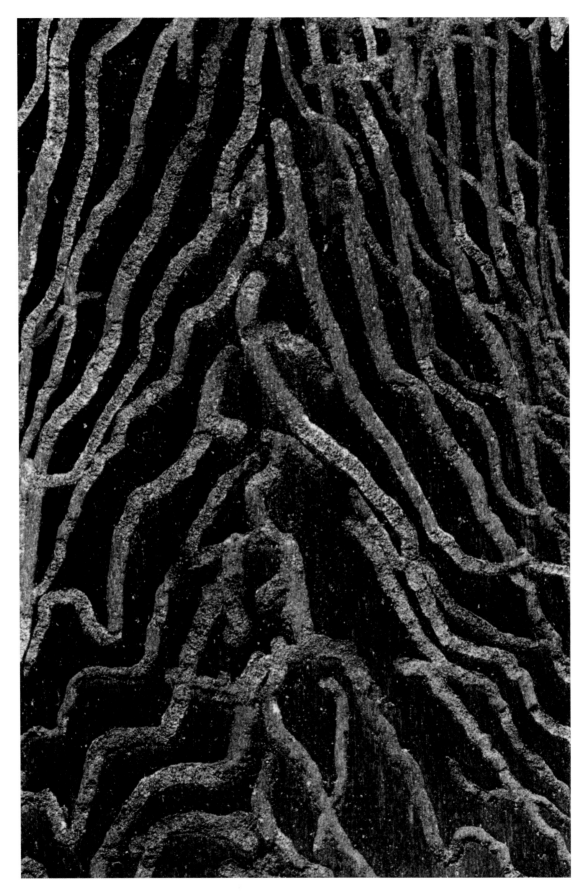

PLATE 55. *Beetle Tracks No. 3*, 2015

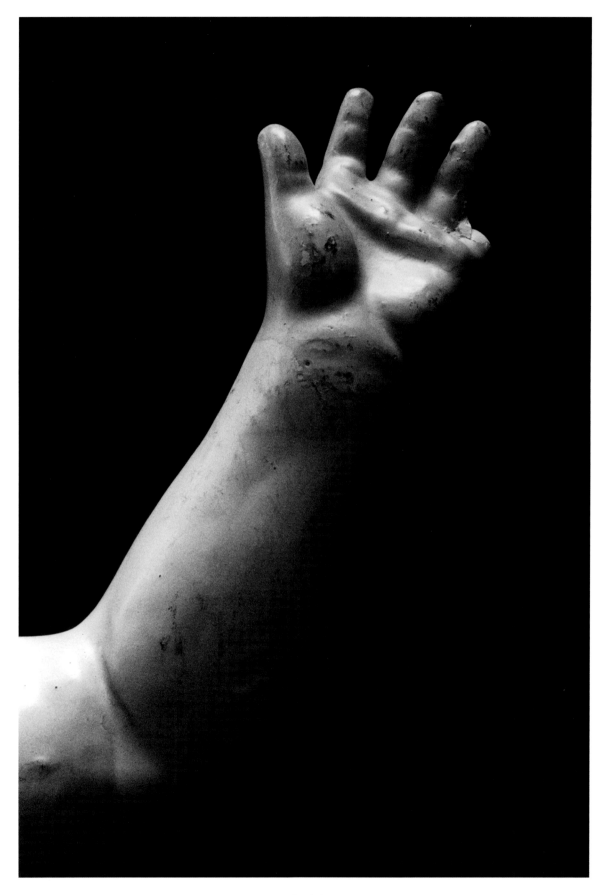

PLATE 56. *Doll Arm*, 2015

Richard S. Buswell

SOLO EXHIBITIONS

2015 Oklahoma State University Museum of Art, Stillwater, Okla.

2014 Paris Gibson Square Museum of Art, Great Falls, Mont.

2013 Montana Museum of Art & Culture, University of Montana, Missoula, Mont.

2011–2012 *Treasured Montana Artist*, Montana State Capitol Building, Helena, Mont.

2011 Housatonic Museum of Art, Bridgeport, Conn.

2011 Appleton Museum of Art, Ocala, Fla.

2011 South Dakota Art Museum, South Dakota State University, Brookings, S.Dak.

2010 Holter Museum of Art, Helena, Mont.

2008–2009 Springfield Museum of Fine Arts, Springfield, Mass.

2008 Gallery and Museum, University of Montana Western, Dillon, Mont.

2008 Nora Eccles Harrison Museum of Art, Utah State University, Logan, Utah

2007 Montana Museum of Art & Culture, University of Montana, Missoula, Mont.

2006 Nora Eccles Harrison Museum of Art, Utah State University, Logan, Utah

2006 Museum of the Rockies, Montana State University, Bozeman, Mont.

2005 Prichard Art Gallery, University of Idaho, Moscow, Idaho

2005 Booth Western Art Museum, Cartersville, Ga.

2005 Holter Museum of Art, Helena, Mont.

2004 International Photography Hall of Fame and Museum, Oklahoma City, Okla.

2004 Western Heritage Center, Billings, Mont.

2004 Gallery and Museum, University of Montana Western, Dillon, Mont.

2002–2003 Paris Gibson Square Museum of Art, Great Falls, Mont.

2002 Montana Museum of Art & Culture, University of Montana, Missoula, Mont.

2002 Northwest Art Center, Minot State University, Minot, N.Dak.

2002 Medicine Hat Museum and Art Gallery, Medicine Hat, Alberta

2001 Iris and B. Gerald Cantor Art Gallery, College of the Holy Cross, Worcester, Mass.

2001 Braithwaite Fine Arts Gallery, Southern Utah University, Cedar City, Utah

2001 Plains Art Museum, Fargo, N.Dak.

2001 Hockaday Museum of Art, Kalispell, Mont.

2000 MonDak Heritage Center, Sidney, Mont.

2000 The Emerson at Beall Park Art Center, Bozeman, Mont.

2000 Holter Museum of Art, Helena, Mont.

1999 BICC Gallery, Oregon Health & Science University, Portland, Ore.

1999 Frye Art Museum, Seattle, Wash.

1999 Kimball Art Center, Park City, Utah

1999 Arts Chateau, Butte, Mont.

1999 Gallery and Museum, University of Montana Western, Dillon, Mont.

1998 Center for Arts & History, Lewis-Clark State College, Lewiston, Idaho

1998 Copper Village Museum and Arts Center, Anaconda, Mont.

1997 John B. Davis Gallery, Department of Art, Idaho State University, Pocatello, Idaho

1996 Department of Fine Arts, Carroll College, Helena, Mont.

1993 Western Heritage Center, Billings, Mont.

1993 Gallery and Museum, University of Montana Western, Dillon, Mont.

1992 Holter Museum of Art, Helena, Mont.

1992 Paxson Gallery, Museum of Fine Arts, University of Montana, Missoula, Mont.

SELECT GROUP EXHIBITIONS

2015 *Coordinates*, Madison Museum of Contemporary Art, Madison, Wisc.

2015 *Recent Acquisitions and Favorites*, Masur Museum of Art, Monroe, La.

2015 87th Annual Juried Exhibition, Art Association of Harrisburg, Harrisburg, Pa.

2015 28th McNeese National Works on Paper, McNeese State University, Lake Charles, La.

2015 Americas 2015: Paperworks Competition, Northwest Art Center, Minot State University, Minot, N.Dak.

2015 36th Annual Paper in Particular Exhibition, Columbia College, Columbia, Mo.

2014–2015 *Northwest in the West: Exploring Our Roots*, Tacoma Art Museum, Tacoma, Wash.

2014 *Expressive Voice: Brought to Light*, Danforth Art Museum, Framingham, Mass.

2014 27th McNeese National Works on Paper, McNeese State University, Lake Charles, La.

2014 2014 20" × 20" × 20": National Compact Competition and Exhibit, Union Art Gallery, Louisiana State University, Baton Rouge, La.

2014 37th Annual Art on Paper Exhibition National Juried Exhibition, Maryland Federation of Art, Annapolis, Md.

2014 *Sharing a Journey: Building the Oklahoma State University Museum of Art Collection*, Oklahoma State University Museum of Art, Stillwater, Okla.

2013–2014 *In Tandem: Established and Emerging Contemporary Artists from the Permanent Collection*, Muscarelle Museum of Art, College of William & Mary, Williamsburg, Va.

2013 *Time Exposures*, Great Plains Art Museum, University of Nebraska–Lincoln, Lincoln, Nebr.

2013 *Recent Acquisitions*, Heckscher Museum of Art, Huntington, N.Y.

2013 *Focal Points: American Photography since 1950*, Madison Museum of Contemporary Art, Madison, Wisc.

2013 *Selections from the Permanent Collection*, Swope Art Museum, Terre Haute, Ind.

2013 Americas 2013: All Media Exhibition, Northwest Art Center, Minot State University, Minot, N.Dak.

2013 36th Annual Art on Paper Exhibition National Juried Exhibition, Maryland Federation of Art, Annapolis, Md.

2013 *Selections from the Permanent Collection*, Harwood Museum of Art, Taos, N.Mex.

2013 85th Annual Juried Exhibition, Art Association of Harrisburg, Harrisburg, Pa.

2013 8th Photographic Image Biennial Exhibition, Wellington B. Gray Gallery, East Carolina University, Greenville, N.C.

2013 Valdosta National 2013 All-Media Juried Competition, Valdosta State University, Valdosta, Ga.

2013 28th Annual International Exhibition, University of Texas at Tyler, Tyler, Tex.

2012–2013 *Collecting Focus: New Prints and Photographs*, Syracuse University Art Galleries, Syracuse, N.Y.

2012 2012 Harnett Biennial of American Prints, Joel and Lila Harnett Museum of Art, University of Richmond Museums, Richmond, Va.

2012 *Photography from the Twentieth Century: The Art Museum Collection, Part 1*, University of Wyoming Art Museum, Laramie, Wyo.

2012 *Selections from the Permanent Collection*, University of Maine Museum of Art, Bangor, Maine

2012 35th Annual Art on Paper Exhibition National Juried Exhibition, Maryland Federation of Art, Annapolis, Md.

2012 Louisiana 25th McNeese National Works on Paper, McNeese State University, Lake Charles, La.

2012 84th Annual Juried Exhibition, Art Association of Harrisburg, Harrisburg, Pa.

2012 *Permanent Collection: Featuring Recent Acquisitions*, Lancaster Museum of Art, Lancaster, Penn.

2012 *Photography from the Permanent Collection*, Lamar Dodd Art Center, Lagrange College, LaGrange, Ga.

2012 Valdosta National 2012 All-Media Juried Competition, Valdosta State University, Valdosta, Ga.

2012 33rd Annual Paper in Particular Exhibition, Columbia College, Columbia, Mo.

2012 Americas 2012: Paperworks Competition, Northwest Art Center, Minot State University, Minot, N.Dak.

2011 *About Architecture: Selections from the Permanent Collection*, Downtown Gallery, University of Tennessee, Knoxville School of Art, Knoxville, Tenn.

2011 2011 20" × 20" × 20": National Compact Competition and Exhibit, Union Art Gallery, Louisiana State University, Baton Rouge, La.

2011 *Velocity from the Permanent Collection*, Museum of Northwest Art, La Conner, Wash.

2011 *Selections from the Permanent Collection*, University of Maine Museum of Art, Bangor, Maine

2011 24th September Competition Exhibition, Alexandria Museum of Art, Alexandria, La.

2011 Americas 2011: All Media Competition, National Juried Exhibition, Northwest Art Center, Minot State University, Minot, N.Dak.

2011 *Photography from the Permanent Collection*, Springfield Art Museum, Springfield, Mo.

2011 *Recent Acquisitions*, Appleton Museum of Art, Ocala, Fla.

2011 *Picturing Technology: Land and Machine*, Madison Museum of Contemporary Art, Madison, Wis.

2011 54th Chautauqua Annual Exhibition of Contemporary Art, Visual Arts at Chautauqua Institution, Chautauqua, N.Y.

2011 83rd Annual Juried Exhibition, Art Association of Harrisburg, Harrisburg, Pa.

2011 *Under the Big Top: The Fine Art of the Circus in America*, Fleming Museum of Art, University of Vermont, Burlington, Vt.

2011 34th Annual Art on Paper Exhibition National Juried Exhibition, Maryland Federation of Art, Annapolis, Md.

2011 *Point of View: Photographs from the Permanent Collection*, High Museum of Art, Atlanta, Ga.

2011 7th Photographic Image Biennial Exhibition, Wellington B. Gray Gallery, East Carolina University, Greenville, N.C.

2011 26th Annual International Exhibition, Meadows Gallery, University of Texas at Tyler, Tyler, Tex.

2011 32nd Annual Paper in Particular Exhibition, Columbia College, Columbia, Mo.

2011 Americas 2011: Paperworks Competition, Northwest Art Center, Minot State University, Minot, N.Dak.

2010 *New Acquisitions, 2005–2010*, Muscarelle Museum of Art, College of William & Mary, Williamsburg, Va.

2010 2010 20" × 20" × 20ç": A National Compact Competition and Exhibit, Union Art Gallery, Louisiana State University, Baton Rouge, La.

2010 *Surface Tension: Pattern, Texture, and Rhythm in Art from the Collection*, Joel and Lila Harnett Museum of Art, University of Richmond Art Museums, Richmond, Va.

2010 *Essential Forms: Intricate Meanings, Geometric Abstraction from the Permanent Collection*, University Art Museum, Colorado State University, Fort Collins, Colo.

2010 23rd September Competition Exhibition, Alexandria Museum of Art, Alexandria, La.

2010 Artful Photography Exhibition, Maryland Federation of Art, Annapolis, Md.

2010 53rd Chautauqua Annual Exhibition of Contemporary Art, Visual Arts at Chautauqua Institution, Chautauqua, N.Y.

2010 *Recent Acquisitions*, Masur Museum of Art, Monroe, La.

2010 82nd Annual Juried Exhibition, Art Association of Harrisburg, Harrisburg, Pa.

2010 33rd Annual Art on Paper National Juried Exhibition, Maryland Federation of Art, Annapolis, Md.

2010 31st Annual Paper in Particular Exhibition, Columbia College, Columbia, Mo.

2010 Magic Silver 2010, Murray State University, Murray, Ky.

2010 Valdosta National 2010 All-Media Juried Competition, Valdosta State University, Valdosta, Ga.

2010 Americans 2010: Paperworks Competition, Northwest Art Center, Minot State University, Minot, N.Dak.

2009–2010 *Recent Acquisitions to the RAM Permanent Collection*, Rockford Art Museum, Rockford, Ill.

2009 *Recent Acquisitions: Art*, University Museum, Southern Illinois University, Carbondale, Ill.

2009 52nd Chautauqua Annual Exhibition of Contemporary Art, Visual Arts at Chautauqua Institution, Chautauqua, N.Y.

2009 *Home: A National, Juried Exhibition of Origins, Places and Connections*, Attleboro Arts Museum, Attleboro, Mass.

2009 2009 20" × 20" × 20": A National Compact Competition and Exhibit, Union Art Gallery, Louisiana State University, Baton Rouge, La.

2009 Montana Triennial, Missoula Art Museum, Missoula, Mont.

2009 81st Annual Juried Exhibition, Art Association of Harrisburg, Harrisburg, Pa.

2009 Valdosta National 2009 All-Media Juried Competition, Valdosta State University, Valdosta, Ga.

2009 *The Masur Collects*, Masur Museum of Art, Monroe, La.

2009 30th Annual Paper in Particular Exhibition, Columbia College, Columbia, Mo.

2009 *Recent Acquisitions: Collections Project III*, Bates College Museum of Art, Lewiston, Maine

2009 6th Photographic Image Biennial Exhibition, Wellington B. Gray Gallery, East Carolina University, Greenville, N.C.

2009 Americas 2009: Paperworks Competition, Northwest Art Center, Minot State University, Minot, N.Dak.

2008–2009 *Art for All: Selections from the Permanent Collection (2500 BC–Present)*, Saginaw Art Museum, Saginaw, Mich.

2008 21st September Competition Exhibition, Alexandria Museum of Art, Alexandria, La.

2008 51st Chautauqua Annual Exhibition of Contemporary Art, Visual Arts at Chautauqua Institution, Chautauqua, N.Y.

2008 *Art of the American West from the Permanent Collection*, Swope Art Museum, Terre Haute, Ind.

2008 80th Annual Juried Exhibition, Art Association of Harrisburg, Harrisburg, Pa.

2008 Valdosta National 2008 All-Media Juried Competition, Valdosta State University, Valdosta, Ga.

2008 Americas 2008: Paperworks Competition, Northwest Art Center, Minot State University, Minot, N.Dak.

2008 *Modern Photographers*, Allen Memorial Art Museum, Oberlin College, Oberlin, Ohio

2008 *Der Zeitgenosse*, Gallery of Art, Eastern Washington University, Cheney, Wash.

2008 30th Annual Art on Paper National Juried Exhibition, Maryland Federation of Art, Annapolis, Md.

2007–2008 *Legacy: A Decade of Collecting*, Muskegon Museum of Art, Muskegon, Mich.

2007 24th Annual National Juried Exhibition, Berkeley Art Center, Berkeley, Calif.

2007 *Of the Moment: Photographs from the Collection*, Birmingham Museum of Art, Birmingham, Ala.

2007 2007 Holter Museum Art Auction, Holter Museum of Art, Helena, Mont.

2007 20th September Competition Exhibition, Alexandria Museum of Art, Alexandria, La.

2007 Americas 2000: All Media Competition, Northwest Art Center, Minot State University, Minot, N.Dak.

2007 *Perfected Landscapes: Views from the Collection*, Fralin Museum of Art, University of Virginia, Charlottesville, Va.

2007 50th Chautauqua Annual Exhibition of Contemporary Art, Visual Arts at Chautauqua Institution, Chautauqua, N.Y.

2007 9th Annual National Juried Small Works Exhibition, Attleboro Arts Museum, Attleboro, Mass.

2007 ANA 35, Holter Museum of Art, Helena, Mont.

2007 Current Work 2007, Fayetteville State University, Fayetteville, N.C.

2007 34th Annual Juried Competition, Masur Museum of Art, Monroe, La.

2007 30th Annual Art on Paper National Juried Exhibition, Maryland Federation of Art, Annapolis, Md.

2007 22nd Annual Positive/Negative National Juried Art Exhibition, Slocumb Galleries, East Tennessee State University, Johnson City, Tenn.

2007 *Recent Acquisitions from the Permanent Collection*, Birmingham Museum of Art, Birmingham, Ala.

2007 Artists Council 38th Annual National Juried Exhibition, Palm Springs Art Museum, Palm Springs, Calif.

2007 Valdosta National 2007 All-Media Juried Competition, Valdosta State University, Valdosta, Ga.

2006 *The Camera's Eye: Intriguing Images from the Permanent Collection*, Springfield Museum of Fine Arts, Springfield, Mass.

2006 *Selected Photographs from the Bluff Collection and the Telfair Museum of Art*, Telfair Museum of Art, Savannah, Ga.

2006 Art on the Plains 9: 9th Annual Regional Juried Exhibition, Plains Art Museum, Fargo, N.Dak.

2006 19th September Competition Exhibition, Alexandria Museum of Art, Alexandria, La.

2006 Americas 2000: All Media Competition, Northwest Art Center, Minot State University, Minot, N.Dak.

2006 49th Chautauqua Annual Exhibition of Contemporary Art, Visual Arts at Chautauqua Institution, Chautauqua, N.Y.

2006 8th Annual National Juried Small Works Exhibition, Attleboro Arts Museum, Attleboro, Mass.

2006 2006 Holter Museum Art Auction, Holter Museum of Art, Helena, Mont.

2006 Artists Council 37th Annual National Juried Exhibition, Palm Springs Art Museum, Palm Springs, Calif.

2006 29th Annual Art on Paper National Juried Exhibition, Maryland Federation of Art, Annapolis, Md.

2006 *Recent Acquisitions*, Springfield Art Museum, Springfield, Mo.

2006 33rd Annual Juried Competition, Masur Museum of Art, Monroe, La.

2006 2006 20" × 20" × 20": A National Compact Competition and Exhibit, Union Art Gallery, Louisiana State University, Baton Rouge, La.

2006 2006 Harnett Biennial of American Prints, Joel and Lila Harnett Museum of Art, University of Richmond Museums, Richmond, Va.

2006 19th McNeese National Works on Paper, McNeese State University, Lake Charles, La.

2006 Toledo Friends of Photography 2006 National Juried Photographic Exhibition, Center for the Visual Arts Gallery, University of Toledo, Toledo, Ohio

2006 *Selections from the Permanent Collection*, Iris and B. Gerald Cantor Art Gallery, College of the Holy Cross, Worcester, Mass.

2006 *History of Photography Exhibition*, Alice R. and Sol B. Frank Photography Galleries, Chrysler Museum of Art, Norfolk, Va.

2006 Valdosta National 2006 All-Media Juried Competition, Valdosta State University, Valdosta, Ga.

2005–2006 *Curator's Choice: Selections from the Vault*, Columbus Museum, Columbus, Ga.

2005–2006 *Recent Acquisitions*, Memphis Brooks Museum of Art, Memphis, Tenn.

2005 *Black and White and Shades of Gray: Photography without Color*, Herbert Johnson Museum of Art, Cornell University, Ithaca, N.Y.

2005 *Permanent Collection (Photography)*, Georgia Museum of Art, University of Georgia, Athens, Ga.

2005 Art on the Plains 8: 8th Annual Regional Juried Exhibition, Plains Art Museum, Fargo, N.Dak.

2005 10th Annual National Art Exhibition, St. John's University, Queens, N.Y.

2005 18th September Competition Exhibition, Alexandria Museum of Art, Alexandria, La.

2005 Photo National 2005, Lancaster Museum of Art, Lancaster, Pa.

2005 Americas 2000: All Media Competition, Northwest Art Center, Minot State University, Minot, N.Dak.

2005 *Recent Acquisitions: Works on Paper*, Ruth Chandler Williamson Gallery, Scripps College, Claremont, Calif.

2005 2005 Holter Museum Art Auction, Holter Museum of Art, Helena, Mont.

2005 77th Annual Juried Exhibition, Art Association of Harrisburg, Harrisburg, Pa.

2005 28th Annual Art on Paper National Juried Exhibition, Maryland Federation of Art, Annapolis, Md.

2005 32nd Annual Juried Competition, Masur Museum of Art, Monroe, La.

2005 *Recent Acquisitions to the Swope Collection*, Swope Art Museum, Terre Haute, Ind.

2005 20th Annual International Juried Show, Visual Arts Center of New Jersey Center, Summit, N.J.

2005 Fourth Photographic Image Biennial Exhibition, Wellington B. Gray Gallery, East Carolina University, Greenville, N.C.

2005 Americas 2000: Paperworks Competition, Northwest Art Center, Minot State University, Minot, N.Dak.

2005 Valdosta National 2005 All-Media Juried Competition, Valdosta State University, Valdosta, Ga.

2004–2005 *A Celebration of the Image: Photography from the Permanent Collection*, Polk Museum of Art, Lakeland, Fla.

2004 Winter Showcase Invitational, Holter Museum of Art, Helena, Mont.

2004 *The Permanent Collection: A Celebration of Recent Acquisitions, 2000–2004*, Jule Collins Smith Museum of Fine Art, Auburn University, Auburn, Ala.

2004 *Manet, Millet, Picasso and More: New Acquisitions and Loans*, Mount Holyoke College Art Museum, South Hadley, Mass.

2004 ANA 33, Holter Museum of Art, Helena, Mont.

2004 Art on the Plains 7: 7th Annual Regional Juried Exhibition, Plains Art Museum, Fargo, N.Dak.

2004 *Visual Proof!*, 9th Annual Photographic Competition Exhibition, Photographic Center Northwest, Seattle, Wash.

2004 2004 20" × 20" × 20": A National Compact Competition and Exhibit, Union Art Gallery, Louisiana State University, Baton Rouge, La.

2004 27th Annual Art on Paper National Juried Exhibition, Maryland Federation of Art, Annapolis, Md.

2004 Current Work 2004, Fayetteville State University, Fayetteville, N.C.

2004 17th McNeese National Works on Paper, McNeese State University, Lake Charles, La.

2004 *Natural Selections: Interpretations of the Natural World*, Fort Wayne Museum of Art, Fort Wayne, Ind.

2004 *Northwest Biennial: Building Wise*, Tacoma Art Museum, Tacoma, Wash.

2004 6th American Print Biennial, Joel and Lila Harnett Museum of Art, University of Richmond Museums, Richmond, Va.

2004 Rocky Mountain Biennial 2004, Museum of Contemporary Art, Fort Collins, Colo.

2004 25th Annual Paper in Particular Exhibition, Columbia College, Columbia, Mo.

2004 Dishman Competition, Dishman Art Museum, Lamar University, Beaumont, Tex.

2004 Valdosta National 2004 All-Media Juried Competition, Valdosta State University, Valdosta, Ga.

2004 19th Annual International Juried Show, Visual Arts Center of New Jersey Center, Summit, N.J.

2003–2004 *From Ansel Adams to Burk Uzzle: Photographers' Gifts to the Collection*, Museum of Fine Arts, St. Petersburg, Fla.

2003 *Celebrating a Decade of Growth: Selections from the OMA's Permanent Collection*, Orlando Museum of Art, Orlando, Fla.

2003 Winter Showcase Invitational, Holter Museum of Art, Helena, Mont.

2003 Rosenthal International 2003, Fayetteville State University, Fayetteville, N.C.

2003 Art on the Plains 6: 6th Annual Regional Juried Exhibition, Plains Art Museum, Fargo, N.Dak.

2003 38th Annual Open National Exhibition, Fine Arts Institute of the San Bernardino County Museum, Redlands, Calif.

2003 *Selections from the Permanent Collection*, Iris and B. Gerald Cantor Art Gallery, College of the Holy Cross, Worcester, Mass.

2003 *Expanding the Legacy: Kresge Art Museum Collects*, Kresge Art Museum, Michigan State University, East Lansing, Mich.

2003 ANA 32, Holter Museum of Art, Helena, Mont.

2003 *Recent Acquisitions*, Colorado Springs Fine Arts Center, Colorado Springs, Colo.

2003 *Visible Rhythm Exhibition*, San Jose Museum of Art, San Jose, Calif.

2003 26th Annual Art on Paper National Juried Exhibition, Maryland Federation of Art, Annapolis, Md.

2003 18th Annual International Exhibition, Meadows Gallery, University of Texas at Tyler, Tyler, Tex.

2003 13th Annual National Art Competition, Truman State University, Kirksville, Mo.

2003 Current Work 2003, Fayetteville State University, Fayetteville, N.C.

2003 Artists Council 34th Annual National Juried Exhibition, Palm Springs Art Museum, Palm Springs, Calif.

2003 *Recent Acquisitions*, Washington County Museum of Fine Arts, Hagerstown, Md.

2003 18th Annual International Juried Show, Visual Arts Center of New Jersey, Summit, N.J.

2002 Winter Showcase Invitational, Holter Museum of Art, Helena, Mont.

2002 Art on the Plains 5: 5th Annual Regional Juried Exhibition, Plains Art Museum, Fargo, N.Dak.

2002 37th Annual Open National Exhibition, Fine Arts Institute of the San Bernardino County Museum, Redlands, Calif.

2002 New Art of the West 8, Eiteljorg Museum of American Indians and Western Art, Indianapolis, Ind.

2002 ANA 31, Holter Museum of Art, Helena, Mont.

2002 Photo National 2002, Lancaster Museum of Art, Lancaster, Pa.

2002 *Personal Viewpoints*, 7th Annual Photographic Competition Exhibition, Photographic Center Northwest, Seattle, Wash.

2002 *DeCordova Collects: Recent Acquisitions from the Permanent Collection*, DeCordova Museum and Sculpture Park, Lincoln, Mass.

2002 74th Annual Juried Exhibition, Art Association of Harrisburg, Harrisburg, Pa.

2002 7th Annual *In Focus* Juried Photography Exhibition, Center for Arts & History, Lewis-Clark State College, Lewiston, Idaho

2002 *Views and Visions: Montana Landscape Photography*, Museum of the Rockies, Montana State University, Bozeman, Mont.

2002 Works on Paper 2002: Recent Drawing, Prints, and Photographs, Union Art Gallery, Louisiana State University, Baton Rouge, La.

2002 17th Annual International Exhibition, Meadows Gallery, University of Texas at Tyler, Tyler, Tex.

2002 Dishman Competition, Dishman Art Gallery, Lamar University, Beaumont, Tex.

2002 5th American Print Biennial, Joel and Lila Harnett Museum of Art, University of Richmond Museums, Richmond, Va.

2002 17th Annual Positive/Negative National Juried Art Exhibition, Slocumb Galleries, East Tennessee State University, Johnson City, Tenn.

2002 Members Showcase 2002, Berkeley Art Center Association, Berkeley, Calif.

2002 23rd Annual Paper in Particular Exhibition, Columbia College, Columbia, Mo.

2001 11th Annual Center Awards, Center for Photographic Art, Carmel, Calif.

2001 *Light2: Images from the Photography Collections*, Alfred O. Kuhn Library Gallery, University of Maryland, Baltimore County, Baltimore, Md.

2001 Winter Showcase Invitational, Holter Museum of Art, Helena, Mont.

2001 36th Annual Open National Exhibition, Fine Arts Institute of the San Bernardino County Museum, Redlands, Calif.

2001 Art on the Plains 4: 4th Annual Regional Juried Exhibition, Plains Art Museum, Fargo, N.Dak.

2001 Art Equinox 2001: A Regional Survey of Contemporary Art, Paris Gibson Square Museum of Art, Great Falls, Mont.

2001 18th Annual National Juried Exhibition, Berkeley Art Center, Berkeley, Calif.

2001 *Beneath the Surface*, 6th Annual Photographic Competition Exhibition, Photographic Center Northwest, Seattle, Wash.

2001 18th Annual Lewis-Clark National Juried Exhibition, Center for Arts & History, Lewis-Clark State College, Lewiston, Idaho

2001 2001 National Juried Exhibition, Provincetown Art Association and Museum, Provincetown, Mass.

2001 73rd Annual Juried Exhibition, Art Association of Harrisburg, Harrisburg, Pa.

2001 6th Annual *In Focus* Juried Photography Exhibition, Center for Arts & History, Lewis-Clark State College, Lewiston, Idaho

2001 14th Annual ARTStravaganza, Hunter Museum of American Art, Chattanooga, Tenn.

2001 7th Annual National Art Exhibition, St. John's University, Queens, N.Y.

2001 16th Annual National Works on Paper, Meadows Gallery, University of Texas at Tyler, Tyler, Tex.

2001 Current Work 2001, Fayetteville State University, Fayetteville, N.C.

2001 16th Annual International Juried Show, Visual Arts Center of New Jersey, Summit, N.J.

2001 16th Annual Positive/Negative National Juried Art Exhibition, Slocumb Galleries, East Tennessee University, Johnson City, Tenn.

2001 22nd Annual Paper in Particular Exhibition, Columbia College, Columbia, Mo.

2000 35th Annual Open National Exhibition, Fine Arts Institute of the San Bernardino County Museum, Redlands, Calif.

2000 Winter Showcase Invitational, Holter Museum of Art, Helena, Mont.

2000 *American Identities: Land, People, Word, Body, Spirit*, Gibson Gallery, Art Museum at the State University of New York at Potsdam, Potsdam, N.Y.

2000 10th Annual Photography Exhibition, Maryland Federation of Art, Annapolis, Md.

2000 *Forty Freedoms Exhibition—A Northern Rockies Invitational*, Montana Museum of Art & Culture, University of Montana, Missoula, Mont.

2000 Art on the Plains 3: 3rd Annual Regional Juried Exhibition, Plains Art Museum, Fargo, N.Dak.

2000 CrossCurrents: Triennial National Juried Exhibition of Contemporary Art, Walter Anderson Museum of Art, Ocean Springs, Miss.

2000 17th Annual Lewis-Clark National Juried Art Exhibition, Center for Arts & History, Lewis-Clark State College, Lewiston, Idaho

2000 13th Annual ARTstravaganza, Hunter Museum of American Art, Chattanooga, Tenn.

2000 72nd Annual Juried Exhibition, Art Association of Harrisburg, Harrisburg, Pa.

2000 5th Annual *In Focus* Juried Photography Exhibition, Center for Arts & History, Lewis-Clark State College, Lewiston, Idaho

2000 23rd Annual Art on Paper National Juried Exhibition, Maryland Federation of Art, Annapolis, Md.

2000 15th Annual National Works on Paper, Meadows Gallery, University of Texas at Tyler, Tyler, Tex.

2000 *New Photography in the Collection*, Art Museum of Missoula, Missoula, Mont.

2000 12th Annual National Juried Competition, Truman State University, Kirksville, Mo.

2000 21st Annual Paper in Particular Exhibition, Columbia College, Columbia, Mo.

2000 Americas 2000: Paperworks Competition, Minot State University, Minot, N.Dak.

1999–2000 Winter Showcase Invitational, Holter Museum of Art, Helena, Mont.

1999 National Juried Exhibition, Union Art Gallery, Louisiana State University, Baton Rouge, La.

1999 12th Annual ARTstravaganza, Hunter Museum of American Art, Chattanooga, Tenn.

1999 17th Annual National Juried Exhibition, Alexandria Museum of Art, Alexandria, La.

1999 16th Annual Lewis-Clark National Juried Art Exhibition, Center for Arts & History, Lewis-Clark State College, Lewiston, Idaho

1999 Art Equinox 1999: A Regional Survey of Contemporary Art, Paris Gibson Square Museum of Art, Great Falls, Mont.

1999 1999 National Works on Paper, St. John's University, Queens, N.Y.

1999 71st Annual Juried Exhibition, Art Association of Harrisburg, Harrisburg, Pa.

1999 4th Annual *In Focus* Juried Photography Exhibition, Center for Arts & History, Lewis-Clark State College, Lewiston, Idaho

1999 Canyon Country Fine Art Competition, Braithwaite Fine Arts Gallery, Southern Utah University, Cedar City, Utah

1999 Dishman Competition, Dishman Art Gallery, Lamar University, Beaumont, Tex.

1999 Artists Council 30th Annual National Juried Exhibition, Palm Springs Art Museum, Palm Springs, Calif.

1999 Greater Midwest International Exhibition XIV, Central Missouri State University, Warrensburg, Mo.

1999 20th Annual Paper in Particular Exhibition, Columbia College, Columbia, Mo.

1999 14th Annual Positive/Negative National Juried Art Exhibition, Slocumb Galleries, East Tennessee State University, Johnson City, Tenn.

1998–1999 *A Fine and Private Place: Mortality, Monuments and Memories*, Denver Art Museum, Denver, Colo.

1998–1999 *Collections: Recent Northwest Acquisitions*, Tacoma Art Museum, Tacoma, Wash.

1998–1999 Annual Exhibition and Auction, Art Museum of Missoula, Missoula, Mont.

1998–1999 Winter Showcase Invitational, Holter Museum of Art, Helena, Mont.

1998–1999 *The Paving of Paradise: A Century of Photographs of the Western Landscape*, Seattle Art Museum, Seattle, Wash.

1998 33rd Annual Open National Exhibition, Fine Arts Institute of the San Bernardino County Museum, Redlands, Calif.

1998 4th Annual Photographic Competition Exhibition, Photographic Center Northwest, Seattle, Wash.

1998 Dias de Los Muertos Festival, Hockaday Museum of Art, Kalispell, Mont.

1998 16th Annual National Juried Exhibition, Alexandria Museum of Art, Alexandria, La.

1998 15th Annual Lewis-Clark National Juried Art Exhibition, Center for Arts & History, Lewis-Clark State College, Lewiston, Idaho

1998 3rd Annual *In Focus* Juried Photography Exhibition, Center for Arts & History, Lewis-Clark State College, Lewiston, Idaho

1998 11th Annual ARTStravaganza, Hunter Museum of American Art, Chattanooga, Tenn.

1998 1998 National Juried Exhibition, Provincetown Art Association and Museum, Provincetown, Mass.

1998 Montana Interpretations Juried Art Exhibit, Montana Institute of Arts, Butte, Mont.

1998 Artists Council 29th Annual National Juried Exhibition, Palm Springs Art Museum, Palm Springs, Calif.

1998 4th Annual National Art Exhibition, St. John's University, Queens, N.Y.

1998 19th Annual Paper in Particular Exhibition, Columbia College, Columbia, Mo.

1997 Winter Showcase Invitational, Holter Museum of Art, Helena, Mont.

1997 32nd Annual Open National Exhibition, Fine Arts Institute of the San Bernardino County Museum, Redlands, Calif.

1997 ANA 26, Holter Museum of Art, Helena, Mont.

1997 Americas 2000: All Media Competition, Northwest Art Center, Minot State University, Minot, N.Dak.

1997 *Montana, Myths and Reality*, Sutton West Gallery, Center for the Rocky Mountain West, University of Montana, Missoula, Mont.

1997 2nd Annual *In Focus* Juried Photography Exhibition, Center for Arts & History, Lewis-Clark State College, Lewiston, Idaho

1997 Cross Currents Exhibition, Holter Museum of Art, Helena, Mont.

1997 69th Annual Juried Exhibition, Art Association of Harrisburg, Harrisburg, Pa.

1997 14th Annual Lewis-Clark National Juried Art Exhibition, Center for Arts & History, Lewis-Clark State College, Lewiston, Idaho

1997 Dishman Competition, Dishman Art Gallery, Lamar University, Beaumont, Tex.

1997 *Where Do We Live? Images of House and Home from the Permanent Collection*, Art Museum of Missoula, Missoula, Mont.

1997 12th Annual Positive/Negative National Juried Art Exhibition, Slocumb Galleries, East Tennessee State University, Johnson City, Tenn.

1996 Winter Showcase Invitational, Holter Museum of Art, Helena, Mont.

1996 31st Annual Open National Exhibition, Fine Arts Institute of the San Bernardino County Museum, Redlands, Calif.

1996 Kaleidoscope 1996, Department of Fine Arts, Carroll College, Helena, Mont.

1996 Magnum Opus IX, Sacramento Fine Arts Center, Carmichael, Calif.

1996 ANA 25, Holter Museum of Art, Helena, Mont.

1996 68th Annual Juried Exhibition, Art Association of Harrisburg, Harrisburg, Pa.

1996 *Jail Exposures*, Myrna Loy Center, Helena, Mont.

1996 Artists Council 27th Annual National Juried Exhibition, Palm Springs Art Museum, Palm Springs, Calif.

1996 Dishman Competition, Dishman Art Gallery, Lamar University, Beaumont, Tex.

1995 Winter Showcase Invitational, Holter Museum of Art, Helena, Mont.

1995 Kaleidoscope 1995, Department of Fine Arts, Carroll College, Helena, Mont.

1995 Annual Exhibition and Auction, Art Museum of Missoula, Missoula, Mont.

1995 ANA 24, Holter Museum of Art, Helena, Mont.

1995 Chautauqua Art Association Galleries, Chautauqua, N.Y.

1995 Texas National '95, College of Fine Arts, Stephen F. Austin State University, Nacogdoches, Tex.

1995 Artists Council 26th Annual National Juried Exhibition, Palm Springs Art Museum, Palm Springs, Calif.

1995 North Dakota National Juried Exhibition, Minot Art Gallery, Minot, N.Dak.

1995 *Photographing the American West*, Paris Gibson Square Museum of Art, Great Falls, Mont.

1994 Annual Exhibition and Auction, Missoula Museum of the Arts, Missoula, Mont.

1994 Montana Governor's Mansion, Governor's Culture Foundation, Helena, Mont.

1994 *Montana Artists*, Idaho Falls Art Council Gallery, Idaho Falls, Idaho

1994 Pacific Northwest Annual Regional Juried Exhibition, Bellevue Art Museum, Bellevue, Wash.

1994 *Mini Treasures: Art of the West*, Holter Museum of Art, Helena, Mont.

1990–1992 *Montana Reflections: Contemporary Photographs—Historic Visions*, Museum of the Montana State Historical Society, Helena, Mont.

PERMANENT COLLECTIONS, PUBLIC

International

National Photography Collection, National Media Museum, Bradford, England

Scottish National Photography Collection, National Galleries of Scotland, Edinburgh, Scotland

Bibliotheque Nationale de France, Paris, France

Art Gallery of Hamilton, Hamilton, Ontario, Canada

Glenbow Museum, Calgary, Alberta, Canada

Winnipeg Art Gallery, Winnipeg, Manitoba, Canada

Art Gallery of Nova Scotia, Halifax, Nova Scotia, Canada

American

Smithsonian American Art Museum, Washington, D.C.

Museum of Fine Arts, Boston, Boston, Mass.

Corcoran Gallery of Art, Washington, D.C.

Museum of Fine Arts, Houston, Tex.

George Eastman House International Museum of Photography and Film, Rochester, N.Y.

Detroit Institute of Arts, Detroit, Mich.

Denver Art Museum, Denver, Colo.

Seattle Art Museum, Seattle, Wash.

Baltimore Museum of Art, Baltimore, Md.

Brooklyn Museum of Art, Brooklyn, N.Y.

Photographic History Collection, Smithsonian National Museum of American History, Washington, D.C.

Prints and Photographs Division, Library of Congress, Washington, D.C.

Fogg Art Museum, Harvard University Art Museums, Cambridge, Mass.

Yale University Art Gallery, New Haven, Conn.

Yale Collection of Western Americana, Beinecke Library, Yale University, New Haven, Conn.

Nelson-Atkins Museum of Art, Kansas City, Mo.

High Museum of Art, Atlanta, Ga.

Birmingham Museum of Art, Birmingham, Ala.

New Orleans Museum of Art, New Orleans, La.

Worcester Art Museum, Worcester, Mass.

Dallas Museum of Art, Dallas, Tex.

Williams College Museum of Art, Williamstown, Mass.

University of New Mexico Art Museum, Albuquerque, N.Mex.

Bancroft Library, University of California, Berkeley, Berkeley, Calif.

Chrysler Museum of Art, Norfolk, Va.

Indianapolis Museum of Art, Indianapolis, Ind.

Portland Art Museum, Portland, Ore.

Davis Museum, Wellesley College, Wellesley, Mass.

Cincinnati Art Museum, Cincinnati, Ohio

Columbus Museum of Art, Columbus, Ohio

Hood Museum of Art, Dartmouth College, Hanover, N.H.

Archive of Documentary Arts, David M. Rubenstein Rare Book and Manuscript Library, Duke University,
 Durham, N.C.

Everson Museum of Art, Syracuse, N.Y.

Oklahoma City Museum of Art, Oklahoma City, Okla.

University of Virginia Art Museum, Charlottesville, Va.

David Winton Bell Gallery, Brown University, Providence, R.I.

Museum of the American West, Autry National Center, Los Angeles, Calif.

Eiteljorg Museum of American Indians and Western Art, Indianapolis, Ind.

National Cowboy and Western Heritage Museum, Oklahoma City, Okla.

Crocker Art Museum, Sacramento, Calif.

Tacoma Art Museum, Tacoma, Wash.

Museum of Art, Rhode Island School of Design, Providence, R.I.

Berkeley Art Museum and Pacific Film Archive, University of California, Berkeley, Berkeley, Calif.

Huntington Library, Art Collections and Botanical Gardens, San Marino, Calif.

Department of Prints, Drawings and Photographs, New York Public Library, New York, N.Y.

Smith College Museum of Art, Northampton, Mass.

Herbert F. Johnson Museum of Art, Cornell University, Ithaca, N.Y.

Sheldon Memorial Art Gallery and Sculpture Garden, University of Nebraska–Lincoln, Lincoln, Nebr.

Mississippi Museum of Art, Jackson, Miss.

Harn Museum of Art, University of Florida, Gainesville, Fla.

John and Mable Ringling Museum of Art, Florida State University, Sarasota, Fla.

Indiana University Art Museum, Bloomington, Ind.

Collection of Western Americana, Honnold/Mudd Library, Claremont University Consortium, Claremont,
 Calif.

Delaware Art Museum, Wilmington, Del.

Louisiana State University Museum of Art, Baton Rouge, La.

J. Wayne Stark Galleries, University Art Galleries, Texas A&M University, College Station, Tex.

Flint Institute of Arts, Flint, Mich.

Heard Museum, Phoenix, Ariz.

Honolulu Academy of Arts, Honolulu, Hawaii

Arkansas Arts Center, Little Rock, Ark.

Telfair Museum of Art, Savannah, Ga.

Orlando Museum of Art, Orlando, Fla.

El Paso Museum of Art, El Paso, Tex.

Memphis Brooks Museum of Art, Memphis, Tenn.

Mobile Museum of Art, Mobile, Ala.

Dayton Art Institute, Dayton, Ohio

Tampa Museum of Art, Tampa, Fla.

Butler Institute of American Art, Youngstown, Ohio

Grunwald Center for the Graphic Arts, Armand Hammer Museum of Art and Cultural Center, University of California, Los Angeles, Los Angeles, Calif.

Harry Ransom Center, University of Texas, Austin, Tex.

Harold B. Lee Library, Photograph Archives in Special Collections, Brigham Young University, Provo, Utah

Vero Beach Museum of Art, Vero Beach, Fla.

Museum of Photographic Arts, San Diego, Calif.

Madison Museum of Contemporary Art, Madison, Wis.

Heckscher Museum of Art, Huntington, N.Y.

Mint Museum of Art, Charlotte, N.C.

Columbia Museum of Art, Columbia, S.C.

Museum of Fine Arts, St. Petersburg, Fla.

Portland Museum of Art, Portland, Maine

Allen Memorial Art Museum, Oberlin College, Oberlin, Ohio

Nevada Museum of Art, Reno, Nev.

Pensacola Museum of Art, Pensacola, Florida

Swope Art Museum, Terre Haute, Ind.

Utah Museum of Fine Arts, University of Utah, Salt Lake City, Utah

Appleton Museum of Art, Ocala, Fla.

Long Beach Museum of Art, Long Beach, Calif.

Boca Raton Museum of Art, Boca Raton, Fla.

University of Michigan Museum of Art, Ann Arbor, Mich.

Krannert Art Museum and Kinkead Pavilion, University of Illinois at Urbana–Champaign, Champaign, Ill.

Georgia Museum of Art, University of Georgia, Athens, Ga.

Chazen Museum of Art, University of Wisconsin–Madison, Madison, Wis.

Muscarelle Museum of Art, College of William & Mary, Williamsburg, Va.

San Jose Museum of Art, San Jose, Calif.

Patricia and Phillip Frost Art Museum, Florida International University, Miami, Fla.

Grand Rapids Art Museum, Grand Rapids, Mich.

Fort Wayne Museum of Art, Fort Wayne, Ind.

Rockford Art Museum, Rockford, Ill.

Kalamazoo Institute of Arts, Kalamazoo, Mich.

Bowdoin College Museum of Art, Brunswick, Maine

Oklahoma State University Museum of Art, Stillwater, Okla.

Fresno Art Museum, Fresno, Calif.

Contemporary Art Museum, University of South Florida, Tampa, Fla.

Fred Jones Jr. Museum of Art, University of Oklahoma, Norman, Okla.

Special Collections, Alfred O. Kuhn Library, University of Maryland, Baltimore County, Baltimore, Md.

McMullen Museum of Art, Boston College, Chestnut Hill, Mass.

Colorado Springs Fine Arts Center, Colorado Springs, Colo.

Monterey Museum of Art, Monterey, Calif.

Rockwell Museum of Western Art, Corning, N.Y.

Springfield Art Museum, Springfield, Mo.

Palm Springs Art Museum, Palm Springs, Calif.

Snite Museum of Art, University of Notre Dame, Notre Dame, Ind.

International Photography Hall of Fame and Museum, Oklahoma City, Okla.

Hunter Museum of American Art, Chattanooga, Tenn.

Taubman Museum of Art, Roanoke, Va.

Great Plains Art Museum, Center for Great Plains Studies, University of Nebraska–Lincoln, Lincoln, Nebr.

Museum of New Mexico, Santa Fe, N.Mex.

San Antonio Museum of Art, San Antonio, Tex.

Montclair Art Museum, Montclair, N.J.

Davison Art Center, Wesleyan University, Middletown, Conn.

Springfield Museum of Fine Arts, Springfield, Mass.

Palmer Museum of Art, Pennsylvania State University, University Park, Pa.

Frederick R. Weisman Art Museum, University of Minnesota, Minneapolis, Minn.

Mead Art Museum, Amherst College, Amherst, Mass.

Mary and Leigh Block Museum of Art, Northwestern University, Evanston, Ill.

Spencer Museum of Art, University of Kansas, Lawrence, Kans.

Middlebury College Museum of Art, Middlebury, Vt.

Mount Holyoke College Art Museum, South Hadley, Mass.

Western History Collection, Denver Public Library, Denver, Colo.

Museum of Art, Brigham Young University, Provo, Utah

Danforth Museum of Art, Framingham, Mass.

Jane Voorhees Zimmerli Art Museum, Rutgers, the State University of New Jersey, New Brunswick, N.J.

Lowe Art Museum, University of Miami, Coral Gables, Fla.

Syracuse University Art Galleries, Syracuse, N.Y.

Colby College Museum of Art, Waterville, Maine

Amarillo Museum of Art, Amarillo, Tex.

Springfield Museum of Art, Springfield, Ohio

New Britain Museum of American Art, New Britain, Conn.

William Benton Museum of Art, University of Connecticut, Storrs, Conn.

Washington State University Museum of Art, Pullman, Wash.

Kresge Art Museum, Michigan State University, East Lansing, Mich.

Muskegon Museum of Art, Muskegon, Mich.

Roswell Museum and Art Center, Roswell, N.Mex.

Fitchburg Art Museum, Fitchburg, Mass.

University Art Museum, State University of New York at Albany, Albany, N.Y.

University Art Museum, California State University, Long Beach, Long Beach, Calif.

Hilliard University Art Museum, University of Louisiana at Lafayette, Lafayette, La.

Hofstra Museum, Hofstra University, Hempstead, N.Y.

Bates College Museum of Art, Lewiston, Maine

Robert Hull Fleming Museum, University of Vermont, Burlington, Vt.

Lyman Allyn Art Museum, New London, Conn.

Ewing Gallery of Art and Architecture, University of Tennessee, Knoxville, Tenn.

Columbus Museum, Columbus, Ga.

Saginaw Art Museum, Saginaw, Mich.

Booth Western Art Museum, Cartersville, Ga.

Center for Photography at Woodstock, Woodstock, N.Y.

Racine Art Museum, Racine, Wis.

Museum of Northwest Art, La Conner, Wash.

Erie Art Museum, Erie, Pa.

Alexandria Museum of Art, Alexandria, La.

Northwest Museum of Arts and Culture, Spokane, Wash.

Buffalo Bill Historical Center, Cody, Wyo.

University of Kentucky Art Museum, Lexington, Ky.

Jule Collins Smith Museum of Fine Art, Auburn University, Auburn, Ala.

Cameron Art Museum, Wilmington, N.C.

Polk Museum of Art, Lakeland, Fla.

University Museum, Southern Illinois University, Carbondale, Ill.

C. M. Russell Museum, Great Falls, Mont.

Beach Museum of Art, Kansas State University, Manhattan, Kans.

Whatcom Museum of History and Art, Bellingham, Wash.

Nora Eccles Harrison Museum of Art, Utah State University, Logan, Utah

Gregg Museum of Art and Design, North Carolina State University, Raleigh, N.C.

University Art Museum, Colorado State University, Ft. Collins, Colo.

Harwood Museum of Art, University of New Mexico–Taos, Taos, N.Mex.

Ulrich Museum of Art, Wichita State University, Wichita, Kans.

Ogunquit Museum of American Art, Ogunquit, Maine

Hallie Ford Museum of Art, Willamette University, Salem, Ore.

Perlman Teaching Museum, Carleton College, Northfield, Minn.

Mills College Museum of Art, Oakland, Calif.

Richard S. Nelson Gallery and Fine Arts Collection, University of California, Davis, Davis, Calif.

Albrecht-Kemper Museum of Art, Saint Joseph, Mo.

Kennedy Museum of Art, Ohio University, Athens, Ohio

Tweed Museum of Art, University of Minnesota Duluth, Duluth, Minn.

University of Maine Museum of Art, Bangor, Maine

Ruth Chandler Williamson Gallery, Scripps College, Claremont, Calif.

Foosaner Art Museum, Florida Institute of Technology, Melbourne, Fla.

South Dakota Art Museum, South Dakota State University, Brookings, S.Dak.

St. Mary's College Museum of Art, Moraga, Calif.

Brauer Museum of Art, Valparaiso University, Valparaiso, Ind.

University of Wyoming Art Museum, Laramie, Wyo.

DeCordova Museum and Sculpture Park, Lincoln, Mass.

Midwest Museum of American Art, Elkhart, Ind.

Iris and B. Gerald Cantor Art Gallery, College of the Holy Cross, Worcester, Mass.

Joel and Lila Harnett Print Study Center, University of Richmond Museums, Richmond, Va.

Daum Museum of Contemporary Art, Sedalia, Mo.

Housatonic Museum of Art, Bridgeport, Conn.

Philip Muriel Berman Museum of Art, Ursinus College, Collegeville, Pa.

University Art Museum, University of New Hampshire, Durham, N.H.

Masur Museum of Art, Monroe, La.

Lamar Dodd Art Center, LaGrange College, LaGrange, Ga.

Southern Alleghenies Museum of Art, Loretto, Pa.

Yellowstone Art Museum, Billings, Mont.

Montana Museum of Art & Culture, University of Montana, Missoula, Mont.

Jundt Art Museum, Gonzaga University, Spokane, Wash.

Washington County Museum of Fine Arts, Hagerstown, Md.

Nicolaysen Art Museum and Discovery Center, Casper, Wyo.

Plains Art Museum, Fargo, N.Dak.

Art Museum of Missoula, Missoula, Mont.

Northwest Art Center, Minot State University, Minot, N.Dak.

Paris Gibson Square Museum of Art, Great Falls, Mont.

Lancaster Museum of Art, Lancaster, Pa.

Holter Museum of Art, Helena, Mont.

Museum of the Montana State Historical Society, Helena, Mont.

Fine Arts Institute of the San Bernardino County Museum, Redlands, Calif.

Myrna Loy Center, Helena, Mont.

MAJOR PUBLICATIONS

2013 *Close to Home: Photographs*. Albuquerque: University of New Mexico Press.

2007 *Traces: Montana's Frontier Revisited*. Missoula: University of Montana Press and the Montana Museum of Art & Culture, University of Montana.

2004 "Richard Buswell," by Richard Newby. *Black and White Magazine* no. 31 (June): 100–103.

2002 *Silent Frontier: Icons of Montana's Early Settlement*. Missoula: Montana Museum of Art & Culture, University of Montana.

1997 *Echoes: A Visual Reflection*, rev. ed. Missoula: Archival Press, in association with the Museum of Fine Arts, University of Montana.

1992 *Echoes: A Visual Reflection*. Missoula: University of Montana School of Fine Arts. Exhibition catalog. Catalog received first place award for the *In Plant* International Conference Competition In Print '93.